IMAGES
of America

ACTON

IMAGES
of America

ACTON

William A. Klauer

ARCADIA

Copyright © 2001 by William A. Klauer.
ISBN 0-7385-0961-2

First printed in 2001.

Published by Arcadia Publishing,
an imprint of Tempus Publishing, Inc.
2A Cumberland Street
Charleston, SC 29401

Printed in Great Britain.

Library of Congress Catalog Card Number: 2001093047

For all general information contact Arcadia Publishing at:
Telephone 843-853-2070
Fax 843-853-0044
E-Mail sales@arcadiapublishing.com

For customer service and orders:
Toll-Free 1-888-313-2665

Visit us on the internet at http://www.arcadiapublishing.com

CONTENTS

INTRODUCTION

Acton, once known as Concord Village, is located directly west of Concord and, while remote from the center of that town, petitioned the government to become a separate town because "they labor under great difficulties by reason of their remoteness from the place of worship." It became a separate town in July 1735.

Forty years later, Acton's Minutemen were the first to oppose the British as they attempted to cross the North Bridge in Concord to get to the other side of the river, where the town's powder was stored. At that incident, Luther Blanchard was wounded and Capt. Isaac Davis and Abner Hosmer were killed, but the British never crossed the bridge and were driven back toward Boston. Later that day, James Hayward was shot in Lexington and died. Hayward, a schoolteacher, had previously lost toes from an accident and joined the Acton men that morning to resist the British.

After the Revolutionary War, Acton developed slowly and farming was the way of life. By 1840, roads were so much better that Boston became a market for Acton products. The introduction of the railroad in 1844 provided easy access to Boston, and both South and West Acton began to grow.

By 1850, both the South Acton and West Acton villages had train stations with an enclave of icehouses, cider mills, stores, and small cottage industries, and several Acton families opened stores in Boston in which to market the products that were produced in Acton. The first department store in the area was Exchange Hall in South Acton, which was owned by the Tuttle family. Tuttle built his first store in 1844; by the beginning of the Civil War, the enterprise had diversified in many directions. The Faulkner family of South Acton had the first fulling mill, and that enterprise moved into Billerica, Harrisville, and Keene, New Hampshire. Cider and vinegar were produced at several locations in the villages, and thousands of piano stools were built by C. Chadwick and the A. Merriam Company in South Acton in addition to woolen materials for the Civil War from a woolen factory on River Street. In East and North Acton were two pencil factories, which produced thousands of pencils, and there were also sawmills and gristmills. Both East and North Acton had a separate railroad line added in 1872, and these communities utilized the railroad. In 1881, an excellent formation of granite was discovered, and granite was quarried for many years and shipped on the railroad. A resort community developed at Lake Nagog, complete with the Nagog Inn, guesthouses, a recreation hall with pool tables and other amusements, and accommodations for horses, carriages, and motor vehicles.

With the advent of the automobile and better transportation, Acton's residents began to commute to outside industry (such as the Assabet Manufacturing Company in Maynard, the Waltham Watch Company, and the mills in Lowell), and the town slowly transformed from a strong agricultural community, with limited industry, toward a strong residential community.

During the Great Depression, several Acton businesses closed their doors. During World War II, some industries were able to assist with items required for the war effort. After the war, the farms dwindled and, by the end of the 1950s, few farms existed. Also, in the early 1950s, a new highway passed through Acton and made a rapid commute to Boston possible. It drew many from the city who wanted to change their lifestyle and live in the suburbs. Those who owned farms realized that their land was valuable, and the population doubled between 1950 and 1960. While the population doubled, the schools saw a growth that tripled in that period, which necessitated new schools. Since 1960, the town has continued to grow and has recently passed the 20,000 mark.

Today, the town is mostly residential. Currently, there are still three farms that grow vegetables and offer them to both local markets and the Boston market. Most of the farms have been converted to residential space, and some of the larger tracts of land have been purchased for conservation purposes.

Forty-eight years ago, when I was a student of Florence Merriam, our class studied Acton history, and the seed was planted for this publication. Over the decades, I have become acquainted with the town's history through its older citizens, Harold R. Phalen's *History of the Town of Acton*, and the earlier volume, which Rev. James Fletcher wrote in the 1890s. In addition, I have worked with others, such as Betsy Conant at the Acton Historical Society and the late Robert H. Nylander and Fred Kennedy. Combined with Merriam, each of these plus many others managed to provide me with an inordinate amount of information, mostly unwritten. Most of the images included are from the extensive collection of the Acton Historical Society. In addition, I would like to thank the Iron Work Farm, Peggy Hebert, Charlotte Wetherbee, Lucille Cuningham, Betsy Randall, Marsha Fitzpatrick, John McNiff, Jack and Ann Whittier, Jeff Bursaw, the Acton Police Department, the Acton Fire Department, the Acton Historical Commission, and Scott Vanderhoof for providing me with images that are not otherwise available.

I hope the images presented are interesting, educational, and will help to preserve that which survives today. I have tried to capture some of the villages, farms, school classes, factories, churches, and views as they once existed.

In addition, it is my hope that this publication will plant a seed in you that will help you to preserve what you have in your community and to realize that local historical societies need contributions, such as the materials I have presented, so that research and other publications can continue.

Finally, I would like to thank Betsy Conant, Belle Choate, and Brewster Conant for proofreading this book; Megan Dumm of Arcadia Publishing for her expert assistance; and my wife, Amber, for her patience and understanding and for keeping me organized during the process.

One
1835–1885

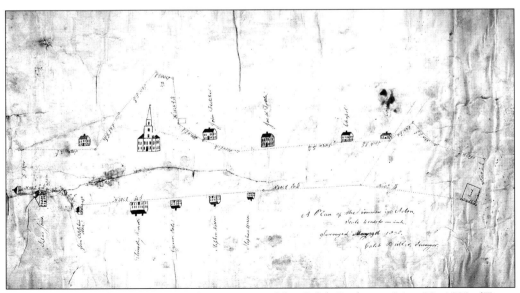

This is a plan of the common in Acton surveyed by Caleb Butler on May 29, 1838. (Town of Acton.)

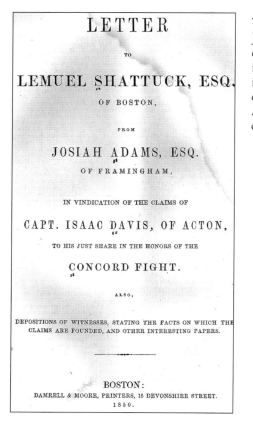

This is a letter to Lemuel Shattuck, Esq., from Josiah Adams, Esq. "In Vindication of the Claims of Captain Isaac Davis of Acton to his just share in the honors of the Concord Fight" was published in 1840 and provided testimony by several of those engaged in the fight, so that the company from Acton would get credit as the first company to challenge the British on April 19, 1775.

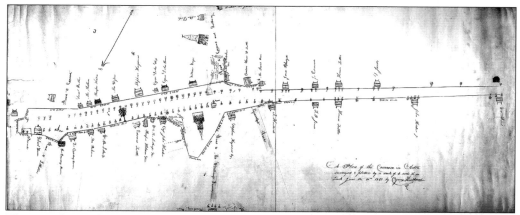

This is a plan of the common in Acton, surveyed on June 20, 1851, by Cyrus Hubbard. It shows later changes, such as the monument and road changes, in pencil. Notable is the fact that there is a shoe manufactory facing the common in the area of the present Spanish-American War Memorial and the hotel and barn that occupied the space between the present fire station and Main Street. (Town of Acton.)

Hanna Davis, the widow of Capt. Isaac Davis, died in 1841 and was buried in Woodlawn Cemetery next to her husband, who was killed at the North Bridge on April 19, 1775. Ten years later, the captain's remains were moved to the monument along with those of Abner Hosmer and James Hayward, who were also killed the same day. (Author's collection.)

Rev. James Trask Woodbury graduated from Harvard University in 1823 with a law degree and was admitted to the New Hampshire bar in 1826. Several years later, he became interested in the ministry and, after more education, served the Evangelical church from 1832 until 1852. During his tenure in Acton, he petitioned the Massachusetts legislature for a sum of money to erect the monument on the town common. His efforts raised $2,500, and the town of Acton raised $500; the monument was dedicated on April 19, 1851. (Author's collection.)

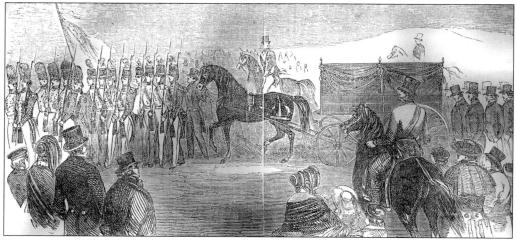

Shown in this view is a funeral procession in April 1851. Prior to the dedication of the monument on April 19, 1851, the remains of Capt. Isaac Davis, Abner Hosmer, and James Hayward were removed from their graves at Woodlawn Cemetery, placed in a three-compartment casket, and put on public view. Following the viewing, the three were buried within the base of the monument, and their headstones were placed adjacent to the monument. (Author's collection.)

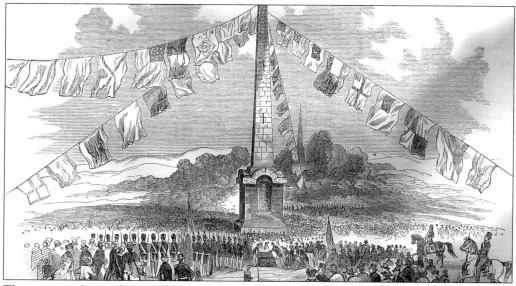

This is an etching of the dedication of the monument on April 19, 1851. The monument contains the following inscription: "The Commonwealth of Massachusetts and the Town of Acton, co-operating in perpetuate the fame of their glorious deeds of patriotism, have erected this monument in honor of Capt Isaac Davis, and Privates Abner Hosmer and James Hayward, citizen soldiers of Acton, and Provincial minute-men, who fell in the Concord Fight, the 19th of April, A.D. 1775. On the morning of that eventful day, the Provincial officers held a council of war near the Old North Bridge in Concord, and, as they separated, Davis exclaimed: 'I haven't a man that is afraid to go' and immediately marched his company from the left to the right of the line, and led in the first organized attack upon the troops of George III, in the memorable war, which, by the help of God, made the thirteen colonies independent of Great Britain; and gave political being to the United States of America. Acton, April 19, 1851."

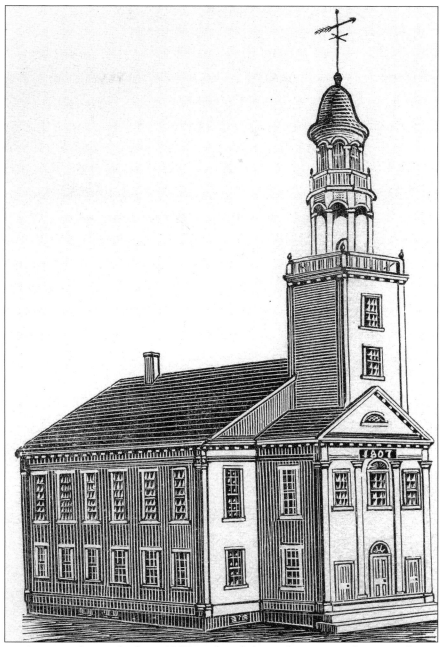

The second meetinghouse, built in 1807, replaced the earlier meetinghouse at the corner of Main Street and Nagog Hill Road, now known as Meeting House Hill. The first meetinghouse had served from the time the town was incorporated. The second one also served for both worship and for town meetings. The building consisted of a main floor with a balcony around three sides and is similar to the First Parish Church in Carlisle in both the date of construction and appearance. As with the Carlisle church, a second floor was constructed by joining the balconies. The building was deeded to the Town of Acton in 1858 and became the town house. In 1862, a fire originated in the tailor's shop building and spread to a barn. Also consumed were the hotel, the Fletcher shoe factory, and, finally, the second meetinghouse.

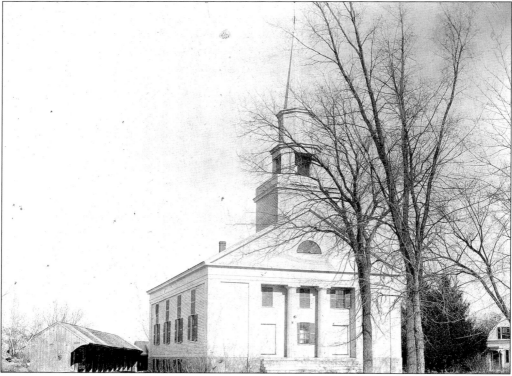

The Acton Center Congregational Church was built *c.* 1833 and faced south. The present building is dated 1846 but may be the 1833 building turned 90 degrees to face west. The steeple was originally central and was moved to the left corner in the late 1890s to give the building a Queen Anne appearance. Noteworthy in this image are the horse sheds, and the semicircular window is the most obvious architectural feature that has not changed during the church's history.

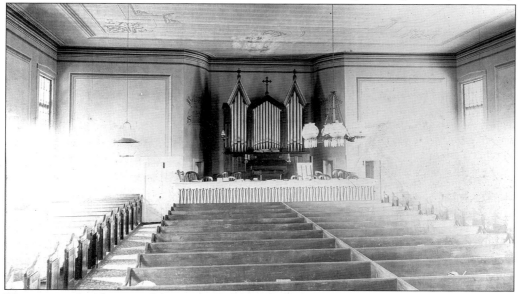

This is an undated image of the interior of the Acton Center Congregational Church after the organ was installed in 1867.

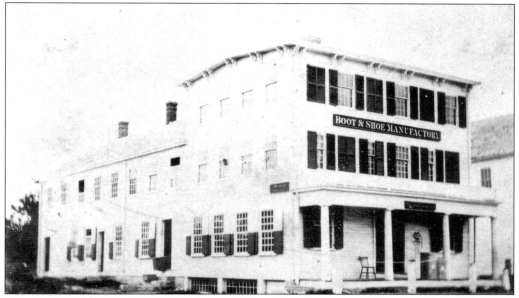

The first John Fletcher & Sons Boot and Shoe Manufactory stood at the south end of the common near the present Spanish-American War Memorial. It appears on the map to be in the middle of what is now Concord Road. The building to the right is the store and tailor shop, where the fire originated in 1862 that burned the factory, barn, hotel, and town house. The shoe factory was replaced along with the hotel and the town hall the following year.

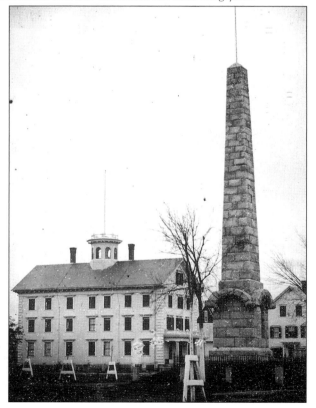

In 1863, the John Fletcher & Sons Boot and Shoe Manufactory was rebuilt on the same location and was similar to the architectural features on the present Acton Town Hall, also rebuilt at the same time. The new factory was three stories in height, had a central cupola with a flagpole on top, and a front porch similar to the town hall. In the background is the Monument House, which replaced a former hotel. Both of these buildings have since burned—the factory in 1893 and the hotel in 1913.

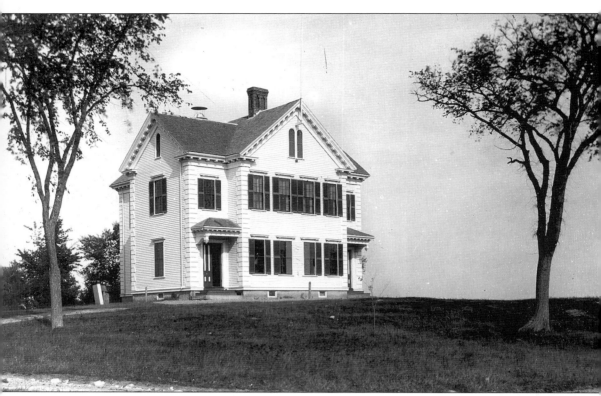

The Acton Center School was built in 1871 and consisted of three rooms—two upstairs and one on the first floor. It continued to be used until the late 1950s as a village school. The structure was torn down *c*. 1962, and the site is now known as Meeting House Hill.

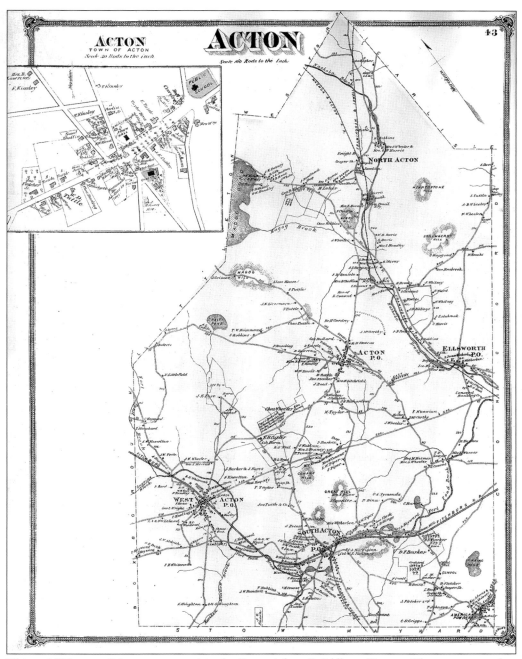

This *c.* 1875 map of Acton appeared in the Beers *Atlas of Middlesex County*. There are a number of items that are worth noting from this document. East Acton was known as Ellsworth until 1883. The East Acton schoolhouse is shown in the area of Harvard Court, and two railroad lines existed side by side until they split at the North Acton Depot.

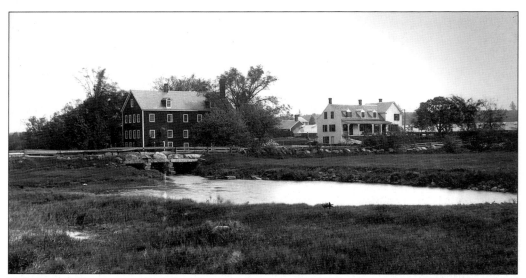

Balls Pencil Factory was built by Ebenezer Davis in 1848. The factory was occupied by A.G. Gray, Lewis Ball, and Henry Smith, who manufactured pencils in the building. Lewis Ball was killed by a bolt of lightning on June 12, 1872, at age 53, and the business was continued by Henry M. Smith. Examples of the company's pencils are on display at the Acton Historical Society. In addition to manufacturing pencils, Henry Smith constructed a number of greenhouses where he grew vegetables extensively. Sometime during the 20th century, the greenhouses were removed. The factory was destroyed by fire on October 17, 1944.

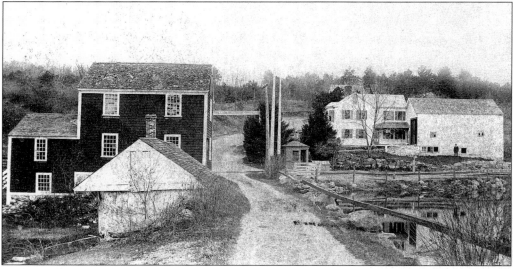

The North Acton Pencil Factory was located on Davis Road when the road went to Main Street. This factory, which produced plumbago (a form of ground graphite), was occupied by Eben Wood and Horace Hosmer (who is listed as a pencil finisher in 1865). The graphite grading equipment may have been in the small structure in front of the building with the windows. It appears that this building had some kind of heating equipment (since it also has a chimney), and the pencils were manufactured in the larger building. The millpond abuts the railroad—hence, the sign that warns anyone using the road to "Watch Out for the Engine." The mill was destroyed many years ago, and the site is now owned by the Town of Acton and used for conservation purposes. The house in the background is 725 Main Street.

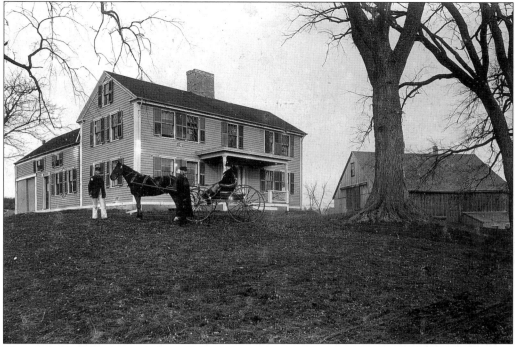

This is the Billings house, where Gallant Insurance is today, at 199 Great Road. The front of this house does not face Great Road, and so this view is deceptive. The barn has been removed, and there have been extensive changes to the ell on the left side of the house.

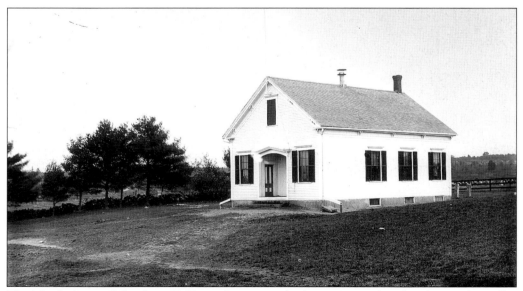

The North Acton School, at 52 Harris Street, was built in 1871 and replaced a much smaller building, which exists down the road. The school was closed in 1896, and the students were transported to the Acton Center School.

The house at 596 Main Street has seen significant changes, but this is an early view of the home when it was owned by James "Fred" Stiles. Stiles is to the right of the tree with his wife and child, and his brother Frank is standing next to the horse. The house was later owned by the John Whittier family until the 1990s. (John and Ann Whittier.)

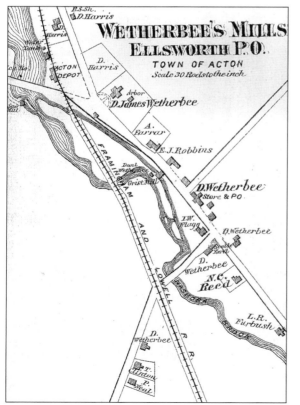

This is a map of East Acton, then known as Wetherbee's Mills or Ellsworth, from the Beers *Atlas of Middlesex County* in 1875. Noteworthy is the sluiceway that fed the equipment at the former gristmill where Bursaw Gas and Oil is today. The Acton Post Office has been moved and is now at 7 Pope Road.

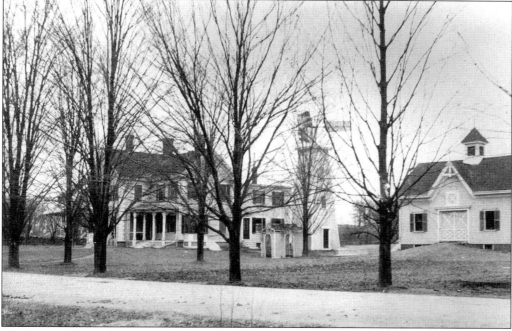

The home of Daniel James Wetherbee was built in 1873 and mirrored the appearance of the Acton Town Hall and John Fletcher & Sons Boot and Shoe Manufactory at the opposite end of Concord Road. The home would have been the focal point of the East Acton village.

In 1840, Daniel Wetherbee built this flour and grain mill at the present site of Bursaw Gas and Oil. It was built on the site where Thomas Wheeler had built his forge. The mill was removed in the early 1930s, and the canal that conveyed water was also filled in.

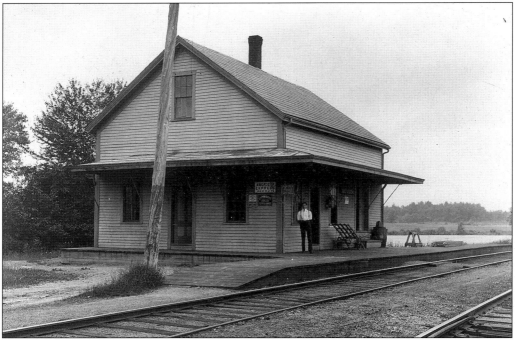

The train depot in East Acton was probably built *c.* 1872 when the railroad went through. In this image, there are two sets of tracks that paralleled one another until they reached North Acton Depot. This structure was moved sometime after 1938, when it closed. At the present time, the site can still be easily detected, as the telegraph pole is visible from Concord Road.

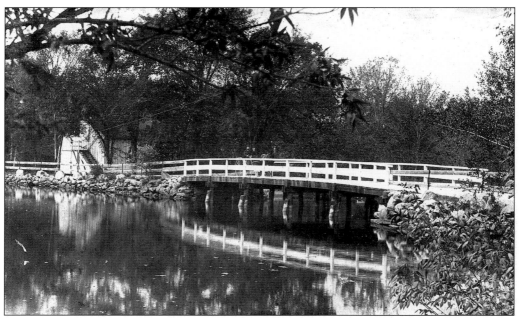

An early bridge, the millpond, and a much smaller icehouse are noteworthy in this *c.* 1880 image. The bridge was later replaced with granite, and, more recently, a new bridge has been installed.

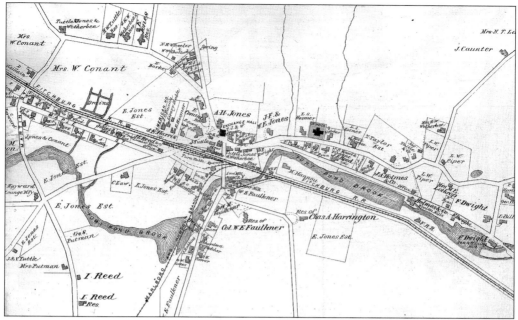

This is a map of South Acton from the Beers atlas of 1875.

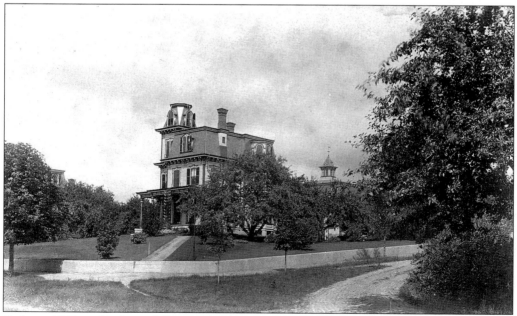

Built in 1873 at 21 Central Street, this house was the home of Elnathan Jones, one of the owners of the Tuttles, Jones and Wetherbee stores in South Acton Square.

George Worster was the son of William W. Worster, the blacksmith, and operated a livery stable for many years at the rear of 27 School Street, now occupied by a repair garage. In this image, he is in front of Zabeth Taylor's house at 80 School Street, known locally as the "Gingerbread House;" however, in this image, we see the house as originally constructed in 1846.

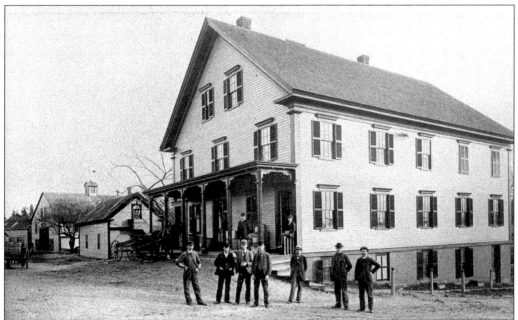

Built in 1866 to replace the original structure destroyed by fire, this building was built to house the grocery and meat enterprise of James Tuttle and Company. The following year, the enterprise welcomed J.K.W. Wetherbee, and the enterprise became known as Tuttles, Jones and Wetherbee.

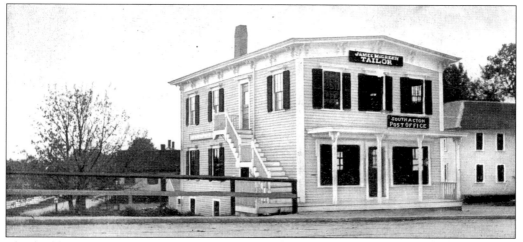

This building is referred to as the "Old Post Office" and was built in 1852 by James Tuttle and Company. On the second floor was Central Hall, and the Universalist Society met here until Exchange Hall was built in 1860. The first floor was used as a tailor's shop. Central Hall was also used as a classroom for the Acton public schools at different times. The Acton Post Office was originally located at a building that was removed when the bridge was added and remained in this building until the 1960s, when it moved to 222 Main Street.

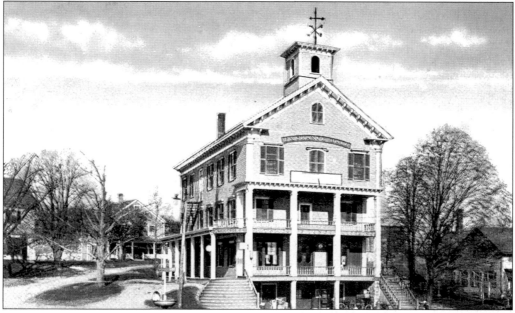

Exchange Hall was built in 1860 to contain the business of James Tuttle and Company and answered the needs of a department store. The structure as built has four separate stories; two are accessible by vehicle, as it is built into a hill. The bottom level was a farmers' exchange—hence the name Exchange Hall. The second and third floors were for everyday commodities, food, clothing, and necessities. The fourth floor contained furniture and items that were not common everyday sales. On Saturday evening, the furniture was lowered to the floor below and stored in the aisles for the dances that were once a common attraction. In addition, the Universalist Society used this hall on Sunday mornings until the society's church was built in 1877.

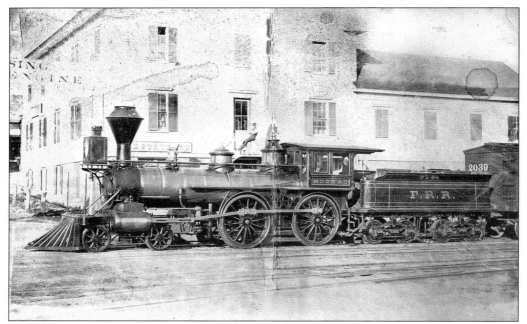

This view was taken on Main Street at the grade crossing. The building behind the train is the rear of the James Tuttle and Company store. The engine belonged to the Fitchburg Railroad. On the left of the store is where Main Street went up the incline, and Exchange Hall would have been slightly to the left.

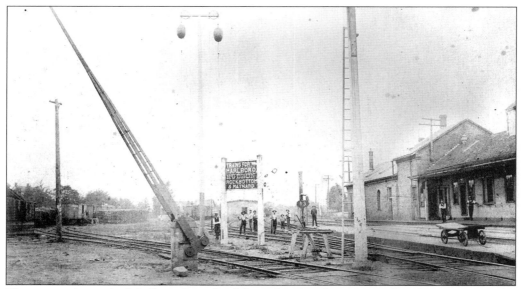

This image shows the Marlboro Branch of the railroad and appears to date from *c.* 1880. The original railroad station freight sheds are to the right and were removed when the bridge was built in 1906.

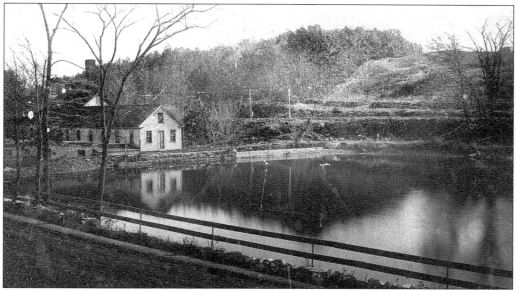

The South Acton Woolen Mill, at 51 River Street, was constructed *c.* 1845 as a sash-and-blind factory. The business lasted for a short time, and the mill became associated with the textile business. During the Civil War, blankets were reportedly made at this location to be shipped to our soldiers. At a later time, wool shoddy was produced here and it became known as the Shoddy Mill. The building burned in 1951. (Wetherbee collection.)

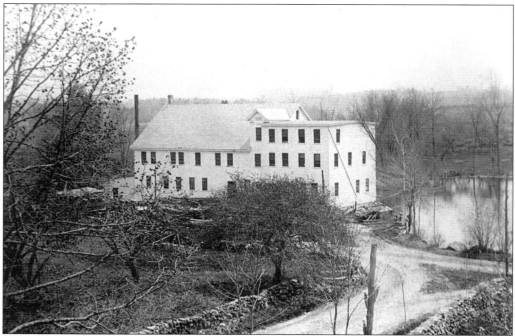

Lewis Wood built a mill at this location *c.* 1831, and it appears that it was long associated with the manufacture of wooden items. In 1878, Cyrus Chadwick leased the buildings and began the manufacture of piano stools. This building burned in 1886 and was rebuilt immediately on the same site. At about this time, Chadwick was joined by Asaph Merriam, who manufactured piano stools in Meriden, Connecticut, and moved his business to Acton. (Iron Work Farm.)

This image was taken from the upstairs of the Lewis Wood mill toward School Street. The house and barn on the left side of the road are at 15 Chadwick Street, and the house on the right was at 14 Chadwick Street and burned in 1969.

This is a close-up view of the house and barn at 15 Chadwick Street. The house was Cyrus Chadwick's residence at the time of this image.

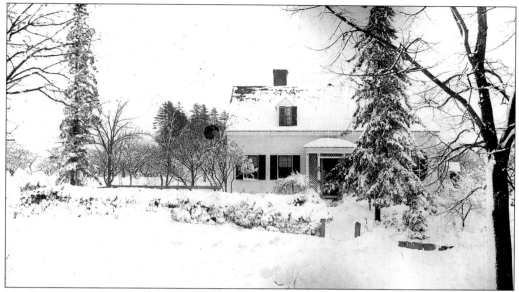

The house at 14 Chadwick Street belonged to the Billings family and the Quimby family. It burned in 1969.

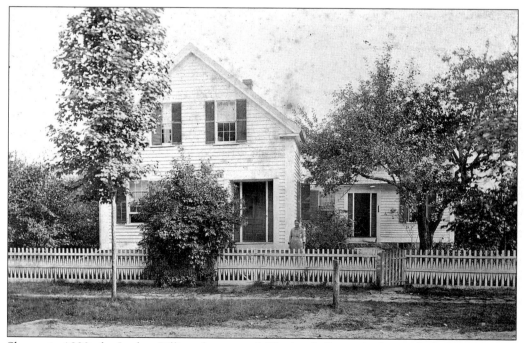

Shown in 1880, the Luther Billings house, at 6 Chadwick Street, looks much the same today.

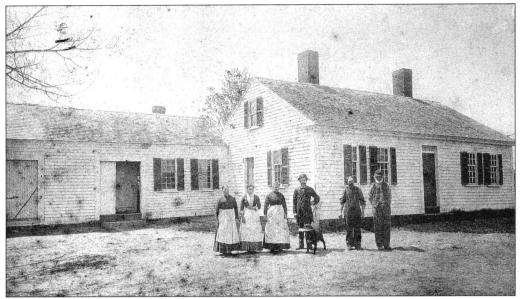

The Josiah Piper house, at 80 Piper Road, may have been moved here during an earlier period of time; however, it does not show up on any earlier maps at another location in the area. In this *c*. 1870 image, the roof of the house begins at the ceiling line. The roof structure was later removed and another half story was added.

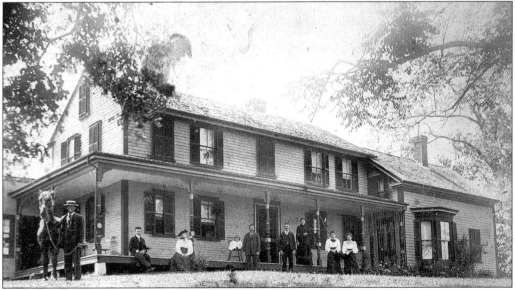

The Abel Farrar family lived at 84 Piper Road for many years and farmed the property. There is still a barn at the residence, but there was once an ell that extended to the edge of Piper Road and a smaller barn into the west side of the present barn. The Bursaw family purchased the farm in the late 1930s and removed the piazzas, the bay window, and the addition to the right.

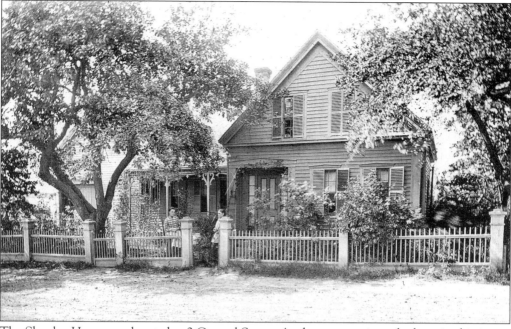

The Shapley House was located at 2 Central Street. At the present time, the barn in this image has been converted into apartments. The house was demolished.

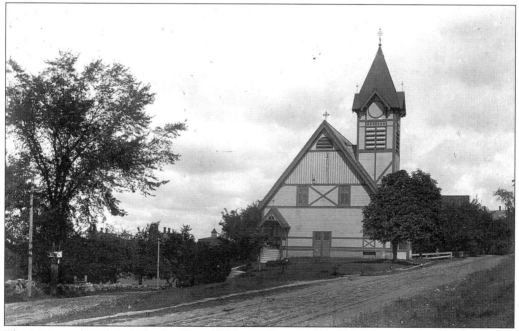

The Universalist church was constructed in 1877 and dedicated on February 21, 1878, by its pastor, Rev. I.C. Knowlton. This was the third and final house of worship for this congregation. There was a full basement, and the church kitchen contained a cistern that was fed by a spring from the hill across the street. Upstairs in the sanctuary were stenciled windows with top panels of stained glass, which opened for ventilation. The building was designed by Ober and Rand of Boston and constructed by George Wood of Concord. It is of the Stick style of architecture.

The cider mill was first constructed by Henry Barker in 1872 and was used to press cider and age it until it turned to vinegar. The mill burned in 1901, and a news item indicated that, due to lack of water, both cider and vinegar were utilized to slow down the destruction by the fire. The building was rebuilt only to burn a second time 50 years later.

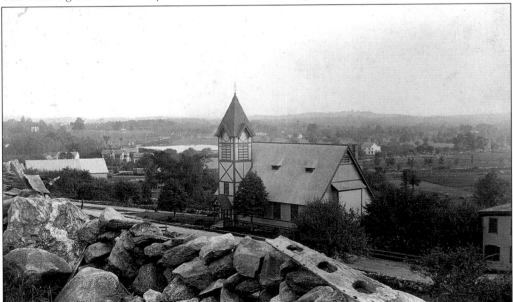

This is a hilltop view of the westerly side of South Acton village taken from the hill that is reached by Nylander Way. The Universalist church dominates the view, and to the right of the church is Barker's Cider Mill. The long roof on the left is Jones's barn on Railroad Street. The view is more interesting due to the lack of trees. Most of the area was used for agricultural purposes.

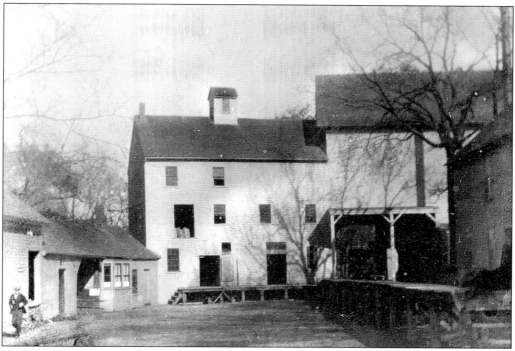

Faulkner's Mills consisted of a number of structures built over a long period of time. As early as 1702, a fulling mill was constructed and other vital operations, such as sawing lumber, grinding of grain, and manufacture of plaster, were performed at this site. The business has been continued by the Erikson family and is still associated with grains.

The Faulkner House is the oldest structure in town and was constructed by Ephraim Jones in 1707. It passed into the Faulkner family shortly after and was owned by six generations of Faulkners between 1738 and 1933. On April 19, 1775, Acton's West Militia Company gathered and was led to the Concord fight by the company's captain, Francis Faulkner.

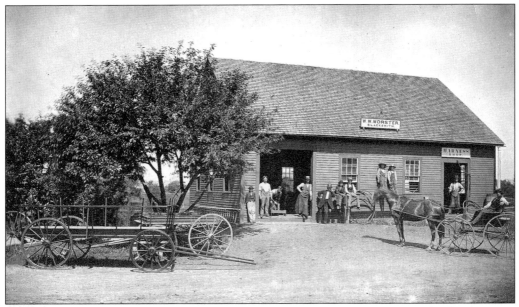

William W. Worster operated a blacksmith shop at 106 Main Street until his death in 1878 at age 50. The shop was built into the hill, and the lower level was equipped with a cradle for lifting oxen to be shod. Worster is probably the gentleman leaning on the right side of the door to the left, and it is likely that the worker in the middle was James Brown, who learned the trade from Worster and later had a shop on Stow Street. (Charlotte Wetherbee.)

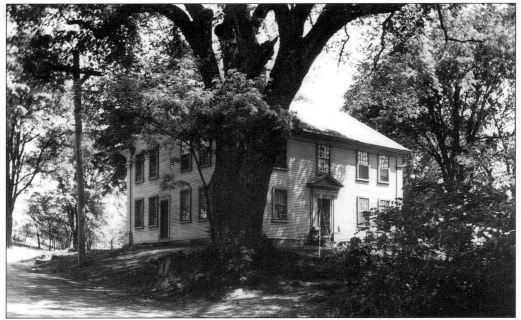

The Hayward-Skinner House, at 298 High Street, was built c. 1801 to replace an earlier structure that burned. This home was once associated with Hayward's Mill, which dates back to c. 1656. The mill was later operated by Abraham Sherman, who sold the water rights to Nathan Pratt. Pratt built several powder mills along the river, and this became one of the leading industries in Acton and one of the most hazardous places to work in.

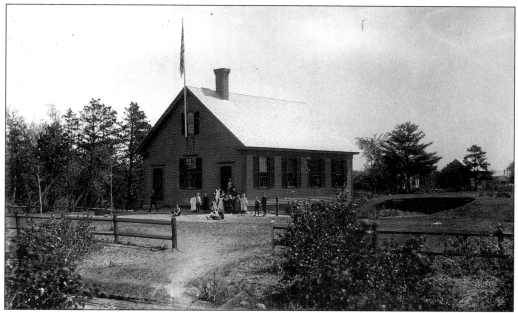

The Southeast School was located south of the intersection of Parker Street and Independence Road near 164 Parker Street. The school committee report for 1849 describes the building as "a very neat structure 22 x 36 feet, one story high, with a room which will accommodate about 40 pupils, also an ample ante-room and wood room." William A. Wilde, who donated the Acton Memorial Library, taught here in 1864. The school closed in 1893, and the pupils were taken by barge to the South Acton School at 54 School Street. The property and school were sold to Samuel Jones Jr. in 1897, and Jones converted it into a house. In 1918, Jorgen Larsen bought it and removed it to his property at 119 Parker Street, where it was converted into the present structure.

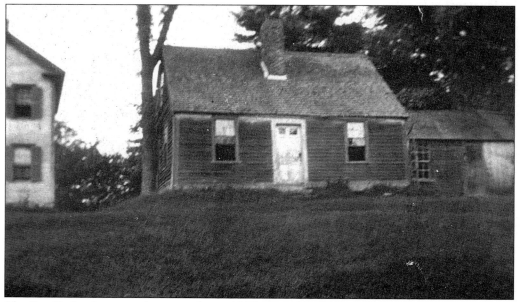

The first Barker house is shown in this c. 1875 image with the new house on the left. The old house has been demolished but stood near 49 Parker Street.

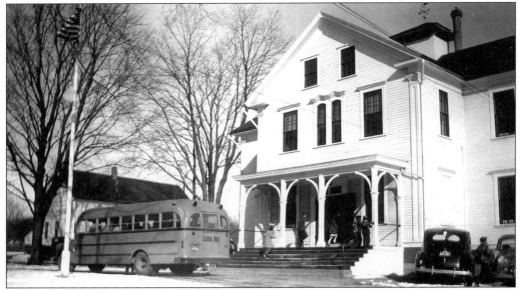

The South Acton School was built in 1872 and served the town as a grammar school until it closed in the late 1950s. It consisted of four rooms, two on each floor, and a full basement that contained the heating apparatus and a laboratory for the Acton High School, which also utilized the building until 1906, when the students of high school age were transported to Concord.

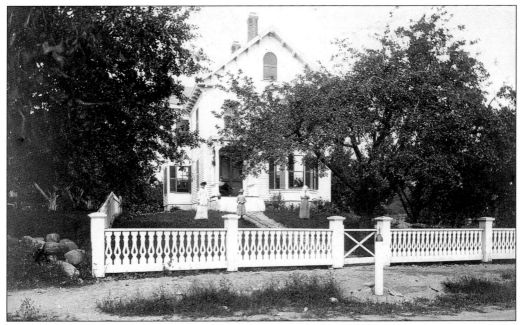

The Ames house was constructed in 1880 by George Ames, and the original contract for the house is in the files of the Acton Historical Commission.

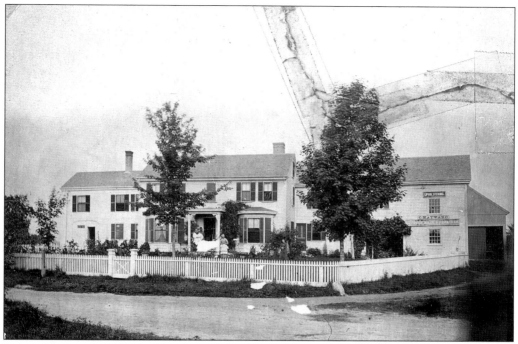

Taken in August 1880 is this view of the Moses Hayward House, at 45 Stow Street. The Haywards were carpenters for many generations and built many of the homes in South Acton. This house was removed c. 1995 and was replaced with a modern structure. (Lucille Hayward Cunningham.)

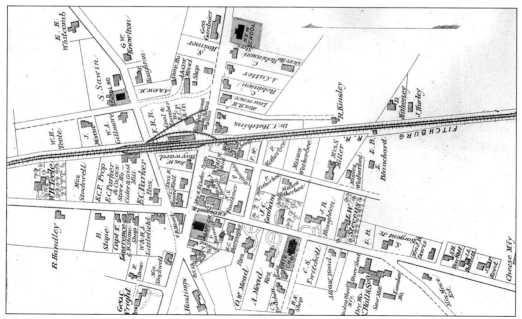

This is a map of West Acton in 1875 from the Beers *Atlas of Middlesex County*.

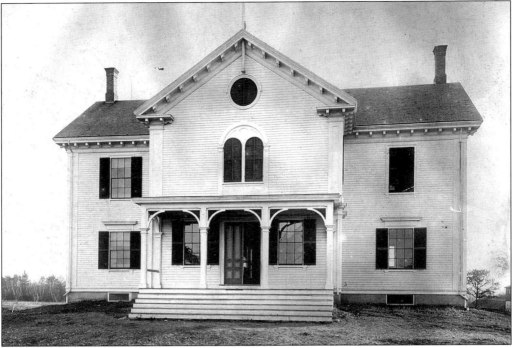

The West Acton School was built in 1872 and served the residents of West Acton with a grammar school until it closed in the 1950s. It was a four-room school with two rooms on each floor and, like the South Acton School, was used for the high school until 1906. It was on the site of the Gardner Playground.

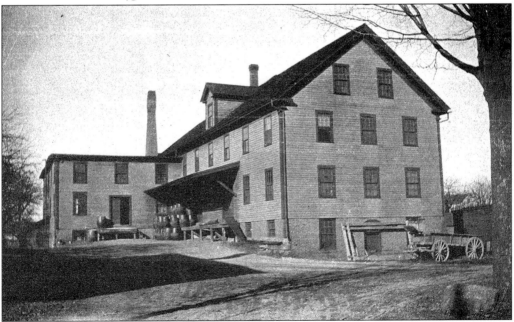

In 1872, Edwin C. Parker constructed a grain and cider mill at 251 Arlington Street, and the mill continued to operate until the late 1950s. It was later torn down and is now the site of Savory Lane.

Between the mill and Central Street, Edwin C. Parker built this house, which was removed *c.* 1950 by Mr. Jenks for the apartments that were constructed.

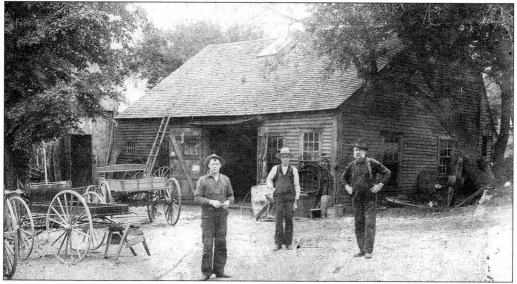

Samuel Guilford had a house at 596 Massachusetts Avenue and a blacksmith shop at 274 Arlington Street. Guilford is listed at this location in 1875 and remained here for many years. He was in business with John McNiff, who came to Acton from Hudson and continued the business at this location after Guilford died. Frank Charter removed the blacksmith shop. Later, the house was moved from the site to create parking for the church.

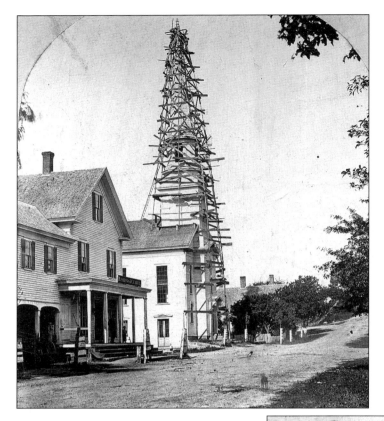

The Baptist church, on the corner of Central Street and Massachusetts Avenue in West Acton, was first constructed in 1846. In 1854, the church burned and was rebuilt on the same location. It would appear that the steeple is being repaired, as there are workers at the top of the scaffolding. The fact that the blinds are not in place could indicate that they are painting the building. (Acton Historical Commission.)

Hastings & Cutlers Store was owned by Charles Hastings, who came to Acton from East Cambridge in 1861, and Nathaniel Cutler. The store operated under this name until it became Cutler Brothers in 1871. During the Civil War, the store collected goods that were shipped out every Monday to be distributed to the troops. (Acton Historical Commission.)

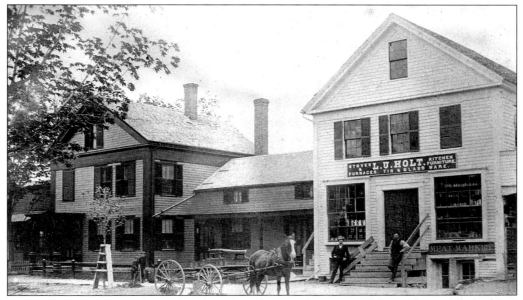

L.U. Holt's tin shop was located at 584 Massachusetts Avenue, and this is the middle building in the block of stores. The tin shop and house to the left were occupied by A.D. Holt in the 1860s; L.U. Holt's name was attached between 1871 and his death in 1892. W.B. Holt succeeded him. The enterprise evolved into a hardware store, and the final owner was Bernard Pond, who liquidated the business *c.* 1972. Lorenzo U. Holt served as the sealer of weights and measures in town between 1880 and 1892. To the right of the shop are carriage sheds that were connected with the store owned by Hastings and Cutler. This photograph was taken *c.* 1880. (Acton Fire Department, donated by the late O.S. Laffin, who dated the photograph.)

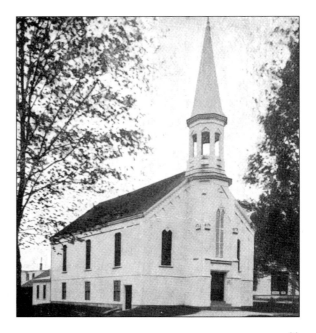

The West Acton Universalist Church was built in 1868 and had formerly utilized Lyceum Hall, which was above the Hastings & Cutlers Store. The congregation merged in 1922 with the South Acton Universalist Church, and Arthur Blanchard purchased the building for the West Acton Women's Club.

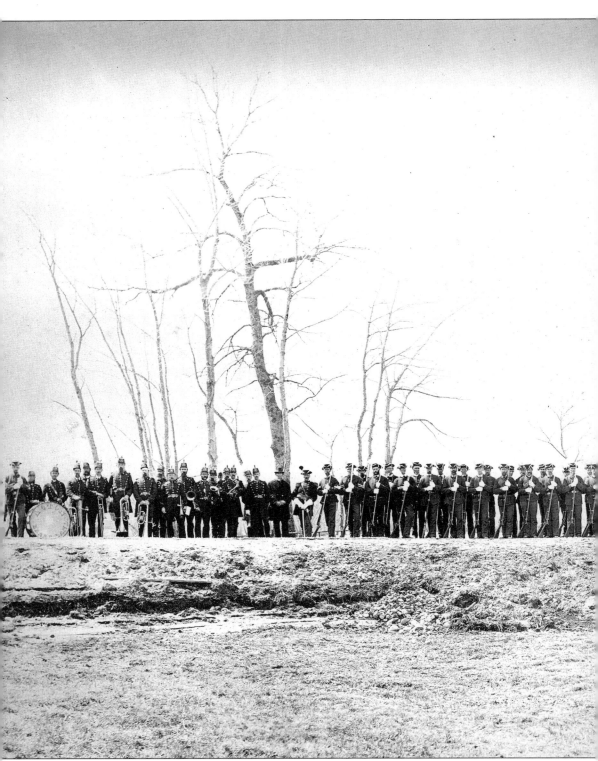

In 1875, there was a centennial celebration in Concord of the battle of April 19, 1775. In this image are Acton Minutemen with the newly created statue by Daniel Chester French of

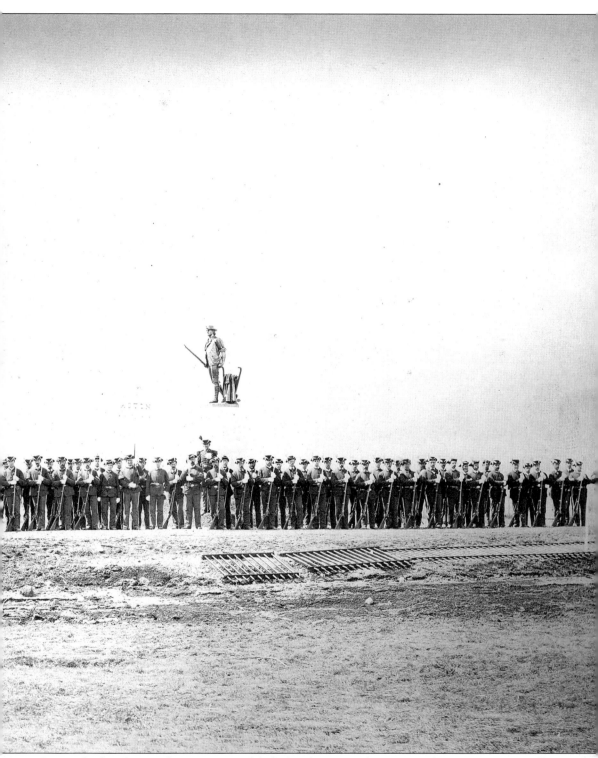

Concord. The plow on the statue is modeled after the Davis plow now in the Acton Town Hall.

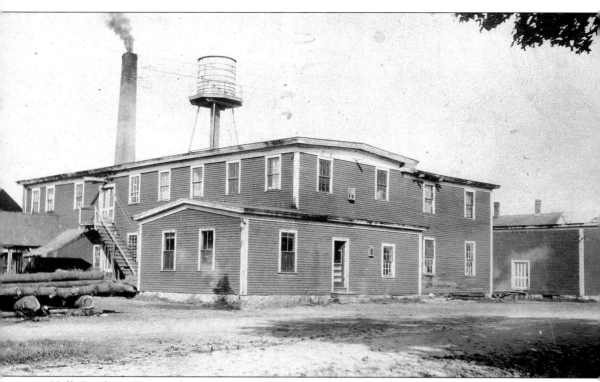

Hall Brothers Factory began to manufacture pails, butter churns, and other woodenware c. 1873. The business had a ready supply of customers because the several cider mills and other local industries provided customers for the woodenware. The business closed during the Great Depression, and the property was acquired by Sid Laffin c. 1940.

Two
1886–1935

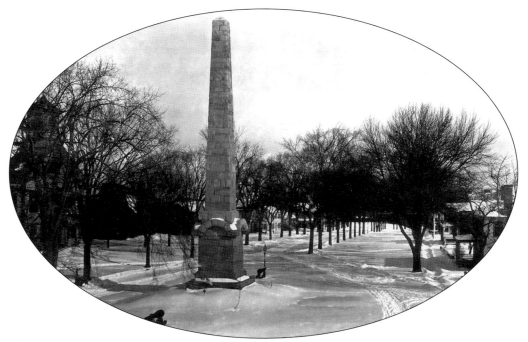

This view of Acton Common by moonlight shows neatly laid-out rows of trees. The photograph dates between 1905, when the cannon was installed, and 1913, when the horse trough at the end of the common was built. When the common was originally laid out, there were two roads, and much of the road we travel today was the common. Imagine the center row of trees as existing on a grass strip in the center and another road to the right of these trees and you can see the second road in this view.

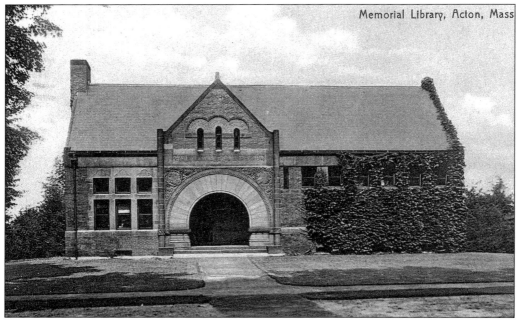

The Acton Memorial Library was built in 1889 as a Civil War memorial for the town. William A. Wilde grew up in South Acton at 119 Parker Street in a house that has since burned and, at a later time, lived at 2 Independence Road.

William A. Wilde gave the library to the town. He was born at 119 Parker Street and taught in the Southeast School several years before moving to Malden.

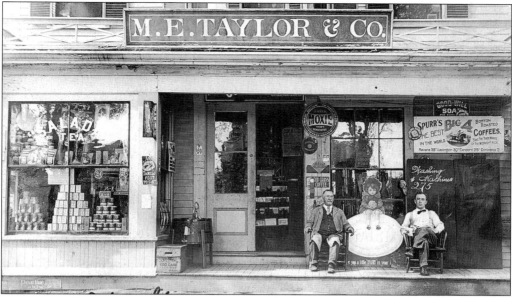

The Center Store was for generations known as Taylor's Store and was operated by this family for many years.

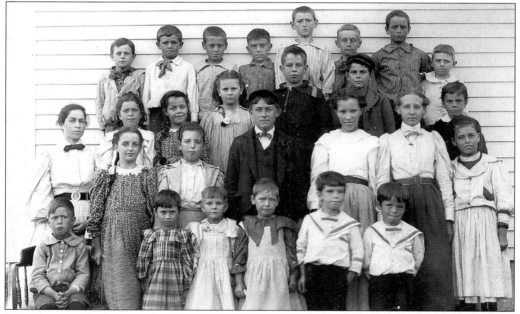

This photograph shows students of the North Acton School in the fall of 1897. The image was taken the last year that the school was used. At about this time, the school was closed and the students were taken to Acton Center School. From left to right are the following: (first row) Florence White, Bertha Harris, Agnes Peterson, Frank Gallagher, and Joseph Gallagher; (second row) Arthur Peterson, Florence Hartwell, Emily Maynes, Clarence Smith, Hattie Harris, Alice McLane, and Mabel Maynes; (third row) Ella Miller (teacher), Helena McCarthy, ? Hartwell, Eva Harris, Willie Hartwell, Bennie Reed, and Alfred Harris; (fourth row) Arthur Harris, George McCarthy, Forrest Spinney, William Pratt, Gaylon Spinney, William Stiles, Harry Hartwell, and Leonard White.

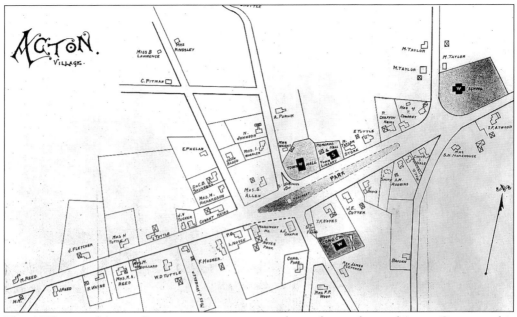

This 1889 map of Acton Center is interesting, as it shows the residents of Acton Center at this time and gives one a perspective of the village at that time. Noteworthy is the fact that the town common runs between Concord Road almost down to Nagog Hill Road. At the intersection of Main Street and Woodbury Lane, beside the Acton Town Hall, are the hay scales, horse trough, and pump. The scales were provided for the use of the residents to weigh produce before going to market to make sure they were not being cheated.

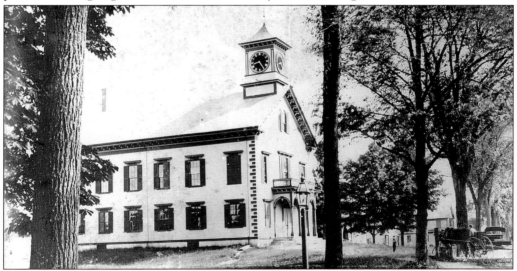

This is a view Acton Town Hall c. 1895 with the recently constructed Acton Memorial Library in the background. The paint scheme of the Acton Town Hall from the time of construction was yellow with brown trim and green blinds. The kerosene lamps were only lit on the moonless nights and, in 1895, the town paid the Acton Center Improvement Society the sum of $161.20 to maintain 65 of the 130 lamps in town. In addition, C.L. Pitman was paid $20 per year for the care of the town clock in addition to raising and lowering the flag on the monument each day. The pump and horse trough are now at the Acton Arboretum.

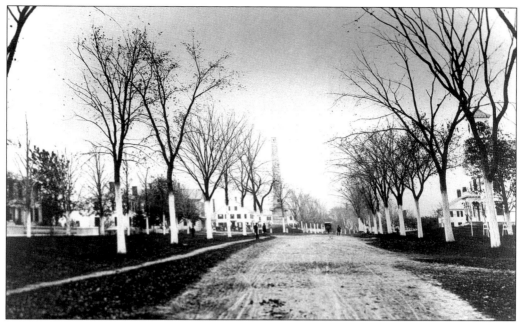

This is a westerly view of the town common *c.* 1900. The common had been set out with rows of trees that succumbed to the Dutch elm disease in the first decade of the 20th century. Beyond the Acton Town Hall on the right is the Hayward house, which burned in 1912, and behind the monument is the hotel that burned the following year.

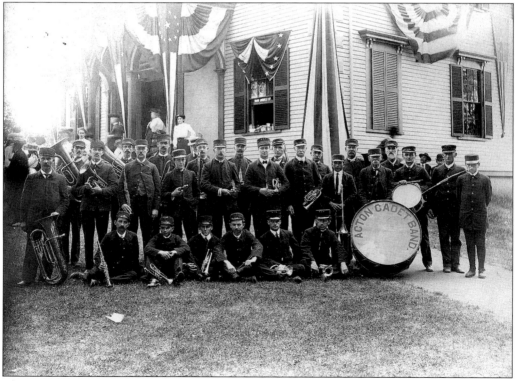

The Acton Cadet Band performed at the 1905 Old Home Week celebration.

The Arthur F. Davis house, at 491 Main Street, is seen in this *c.* 1905 view, with a telephone pole behind the house and a kerosene street lamp in the foreground. The view indicates that the area is mostly farming in the background, as there is a lack of trees. The barn between the houses is now gone, and the house to the right is 487 Main Street, showing the two-story porch that has been recently removed.

This photograph, taken during the 1905 Old Home Week, shows the building at 487 Main Street—known locally as the Boardman House because Dr. Boardman and his family lived here for many years. The house, with its large porch, has been decorated for the event.

The Monument House was a hotel that stood on the vacant lot between 461 Main Street and Concord Road. It was operated for many years by Amos Noyes.

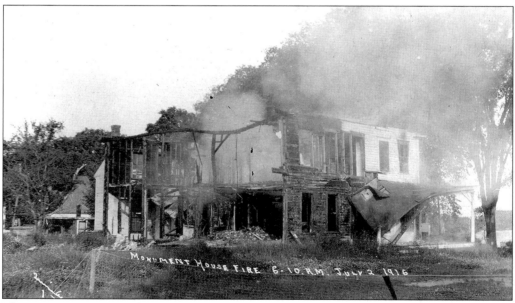

The Monument House burned on July 4, 1913. Kerosene from a barrel set the barn and Monument House on fire. This image was taken of that event.

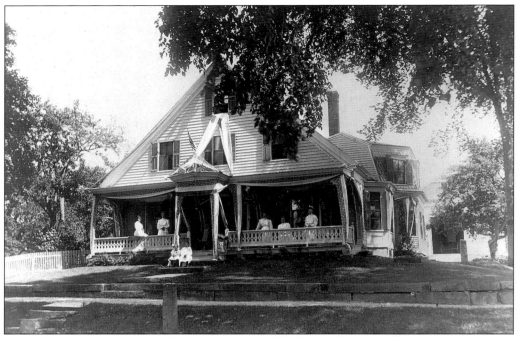

This is a view of the Bancroft House during the 1905 Old Home Week. The house was owned by the Bancroft family during the 20th century. It was renovated by the Johnson family in recent years, and the present barn replaced one that was destroyed in a 1954 hurricane.

The Bean House is pictured during Old Home Week. Forest Bean purchased the house 10 years after this 1905 image. There are still beautiful flowers today, but the pump and watering trough have disappeared.

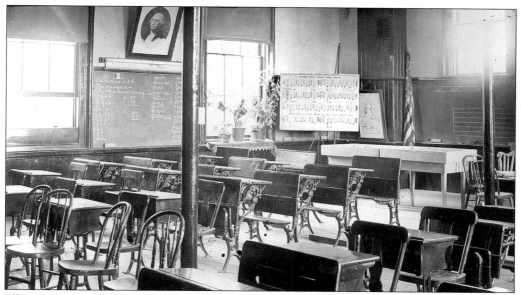

Ella Smith's classroom in the Acton Center School is shown here. Ella Smith taught in this room from 1902 until 1926, when she retired.

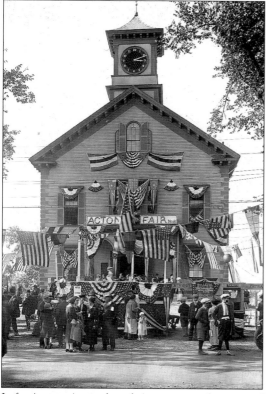

STORY OF "SAMPSON" TOLD BY JAMES EDNEY

Prize Rooster Owned By South Acton 4-H Club Boy Had a Most Remarkable Record

All those who attended the Acton Fair, especially those who visited the Boys' and Girls' Club Exhibit, must have noticed a bright-eyed little boy about twelve years of age, who showed by his talk and actions that he had a better understanding of poultry than many adults.

During a conversation with this boy who by the way is James Edney, of South Acton, he told the editor of this Bulletin a very interesting story about his rooster, which he called "Sampson." Here is his story, using his own words:

"I think I have overworked one of my roosters. I took him to the Acton Fair last year and won second prize on him. Then I brought him home and used him for breeding and I took his children over to the Fair this year and won first and second prizes with them. Then I canned him and took him over to the Fair canned and won first prize on him, and then I took him home, and then—we are going to eat him. I guess that's all."

James has not only been proficient in poultry·club work but he has been an enthusiastic and successful member in the garden, canning and bread clubs in South Acton, and has won prizes exhibiting in all these projects.

Left: Acton Agricultural Association fairs were held on the town common beginning *c.* 1917 until 1942, and this image dates to *c.* 1925. *Right:* The story of Sampson—James P. Edney was the son of Charles and Ester Edney of 39 Martin Street. Jim was deeply interested in agriculture and was later associated with the frozen-food industry. (Randall collection.)

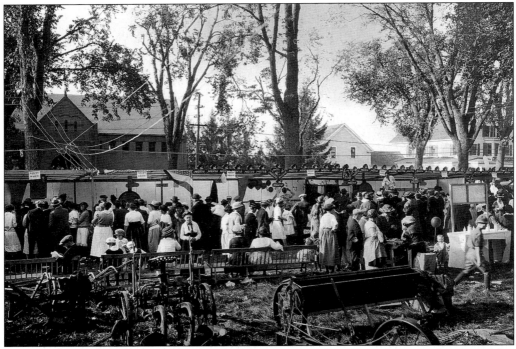

This view shows the 1922 Acton Agricultural Association fair. The exhibits at the annual fair spanned the town common, and there were once buildings behind the Acton Town Hall that were owned by the association for livestock and other exhibits.

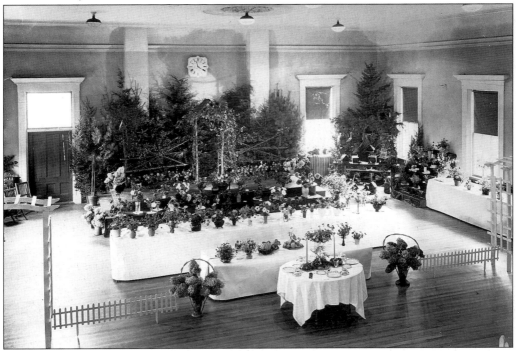

Shown here is the horticultural exhibit on the second floor of the town hall at the Acton Agricultural Association fair *c.* 1932.

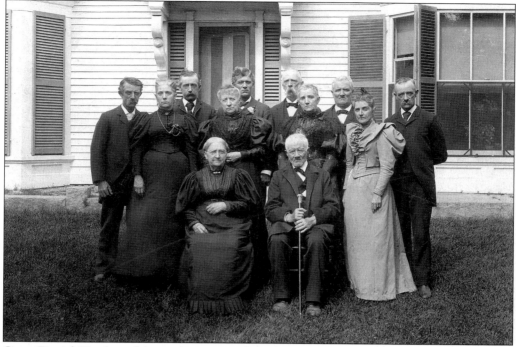

Capt. Daniel Tuttle and his wife are seated in this family photograph at their home at 52 Woodbury Lane. Standing, from left to right, are Arthur Tuttle, two unidentified, Loretta Tuttle, three unidentified, Julian Tuttle, Addie Tuttle Taylor, and James B. Tuttle.

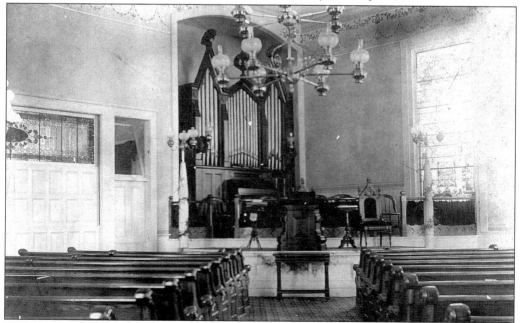

This is an interior view of the Acton Center Congregational Church following the renovation of 1898. Changes included the repositioning of the pulpit, organ, and choir to the right-hand corner of the church and installing stained-glass memorial windows and new pews. Sliding doors on the left side of the room could be opened to increase the size of the sanctuary.

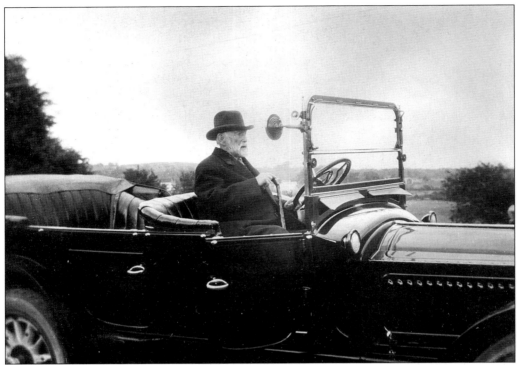

Luther Conant is seen here in his Cadillac. Conant was an educator, and the Conant School at 80 Taylor Road is named to honor him. He also served numerous years as town moderator, beginning in 1861 until 1905, and was president of the board of trustees of the Acton Memorial Library for many years.

This photograph was taken at the 150th anniversary of the battle of 1775. Acton Minutemen posed for this image taken on April 19, 1925, at the Isaac Davis Monument. After this image was taken, everyone walked the original route to Concord and participated in the Concord celebration.

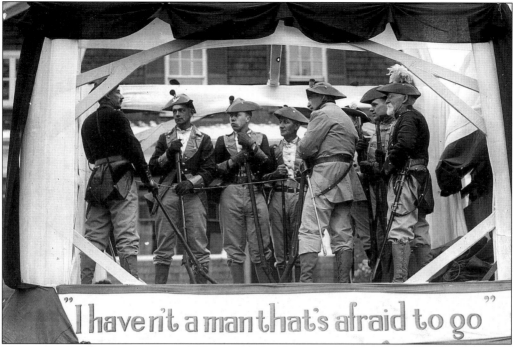

This is Acton's float in the Concord Parade on April 19, 1925. Included on this float are, from left to right, Charles Davis, Andrew Phillips, Henry Soar, Churchill Newman, Arthur F. Davis, Brooks Parker, Cecil Dunn, and Silas H. Taylor.

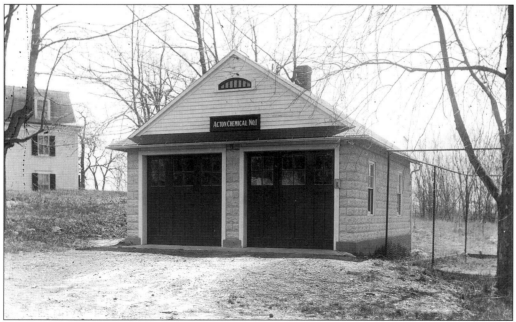

This is the Chemical No. 1 Station, built in 1925. In 1924, the Town of Acton purchased three pieces of fire apparatus. Each was equipped with chemical tanks, and Chemical No. 1 was housed here until 1934, when Engine No. 2, a Reo-Seagrave pumper was purchased. This station was replaced in 1951 with the present fire station. (Author's collection.)

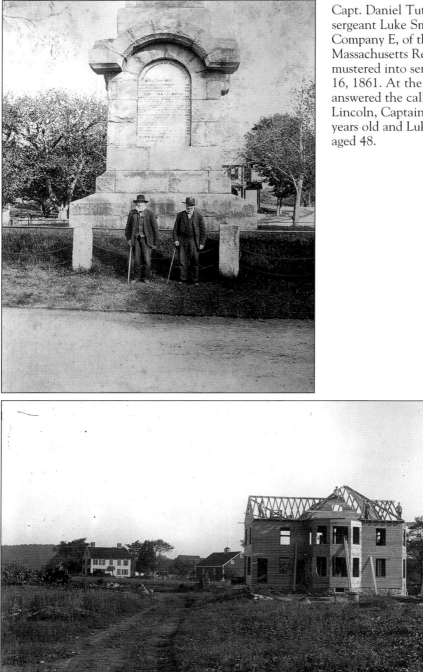

Capt. Daniel Tuttle and orderly sergeant Luke Smith of Company E, of the 6th Massachusetts Regiment, were mustered into service on April 16, 1861. At the time they answered the call from President Lincoln, Captain Tuttle was 47 years old and Luke Smith was aged 48.

Charles Smith was in the process of having this house constructed at 52 Brook Street when this image was taken. The house remained in the family, as his nephew George Greenough later owned it. The house burned on October 31, 1971. The house in the background is 274 Great Road, and the barn stood on the other side of the state highway where Assabet Plaza is located. All the buildings in this image are gone.

Hattie Smith owned this house at 260 Great Road. She was the sister to Charles Smith and remained at this house until her death. The Vigliotti family was the second and final family to live here before it was demolished for the shopping center.

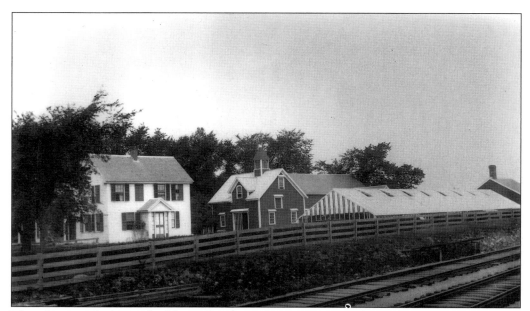

This photograph shows the Henry Smith residence, at 40 Brook Street. Henry Smith was a builder and also the last operator of the pencil factory. He built vast greenhouses on his property and grew vegetables, which he shipped to market during the winter months. He died in 1907, and his family continued the enterprise. In the foreground are the two sets of tracks that ran from East Acton to the North Acton Depot, where they went separate directions.

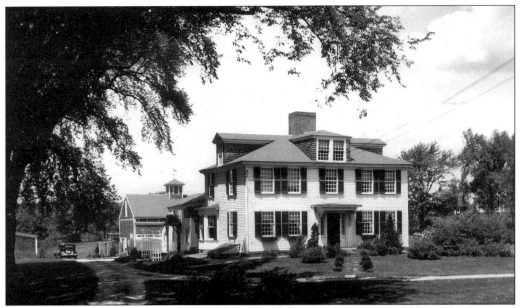

This is a view of the David Davies House, located at 242 Great Road and built during the 1790s. Harvard College petitioned the Massachusetts legislature to hold a lottery to defray the expense of new buildings. The lottery had several cash prizes, and the grand prize was $10,000. Abel Conant of 562 Main Street purchased a $5 ticket and sold a quarter of it to John Robbins, Abraham Skinner, and David Davies. The ticket won the grand prize of $10,000, and each of the four received $2,500. The original part of the house was moved to 160 Great Road, and the attached sheds and barn were destroyed. The property is now the site of Coach Estates, at 53 and 55 Brook Street.

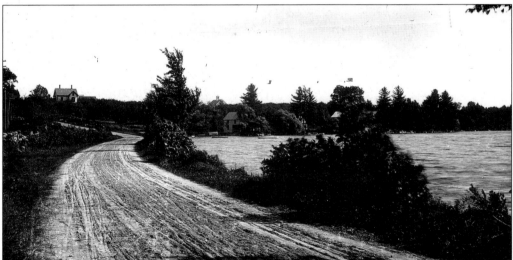

Lake Nagog is seen c. 1900 in a view looking east on Great Road at the intersection of Nagog Park Drive. The lake was a mecca for vacationers, and the shores were dotted with camps. On the easterly side was the property of Chester Robbins, who owned the Lake Nagog Inn, and there were cabins, a playhouse, a boathouse, and other structures that went with the property. The lake became designated as a water supply for the town of Concord, and most of the structures were demolished over the years after recreational use of the lake was banned.

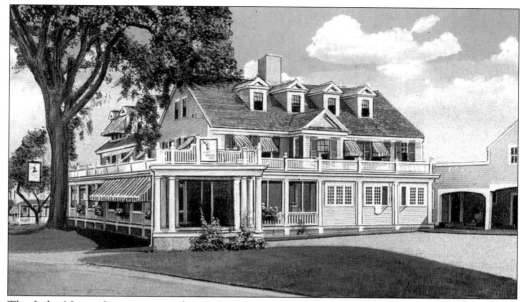

The Lake Nagog Inn once stood at 517 Great Road, and the business was owned by Augusta and Chester Robbins. Old advertising material suggests that the facility could accommodate about 30 guests. In addition, there were several private cabins for families on the lake with a boathouse, and another building had pool tables and other forms of recreation. The lake became a public water supply for the town of Concord, and recreational use of the waters was not permitted. The inn closed during the Great Depression. The buildings on the inn side of the road were torn down, and the property is now the site of Nagog Woods.

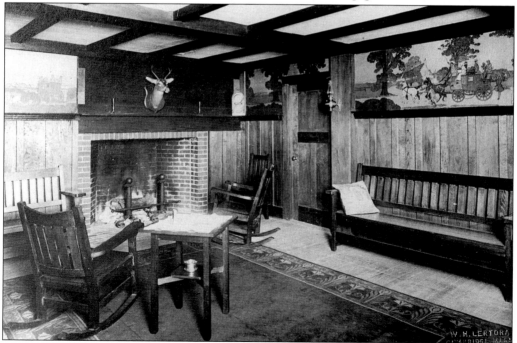

This is an interior view of one of the rooms at the inn. It appears that the furnishings were mostly oak of the Arts and Crafts style.

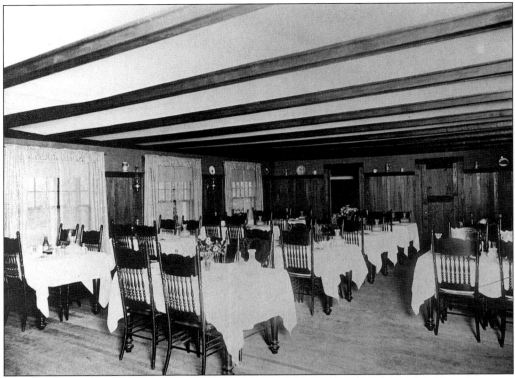

This is a view of the dining room of the Nagog Inn with beamed ceilings.

This house at 510 Great Road with sheds and a barn attached was built by the Lamson family. The house was demolished when Breezy Point was constructed about 10 years ago.

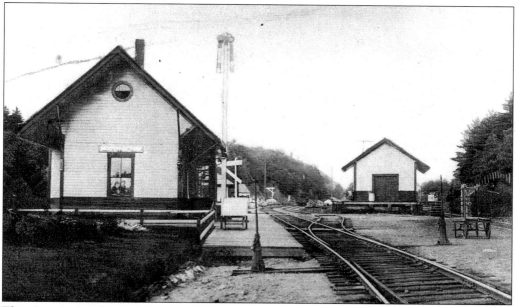

This is a view of the train depot at North Acton. There are two separate sets of tracks shown in this postcard. The second set of tracks is on the extreme right, and the freight shed is between both sets of tracks.

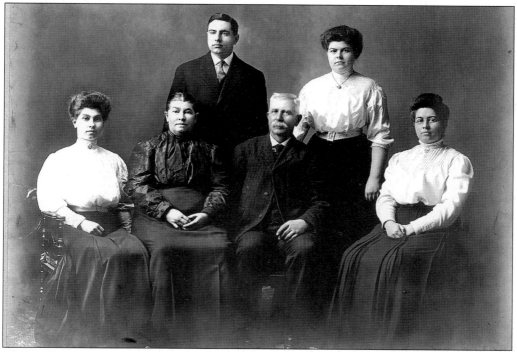

The Miller family lived at 737 Main Street in North Acton, and their daughter Ella was a schoolteacher in both North Acton and Acton Center for many years. This image was taken c. 1900. From left to right are the following: (front row) Alice E. Miller, Lizzie Keys Miller, Charles Miller, and Ella Miller; (back row) Samuel E. Miller and Loraine Miller. Ella Miller was a schoolteacher, and Charles was the North Acton station agent for the railroad.

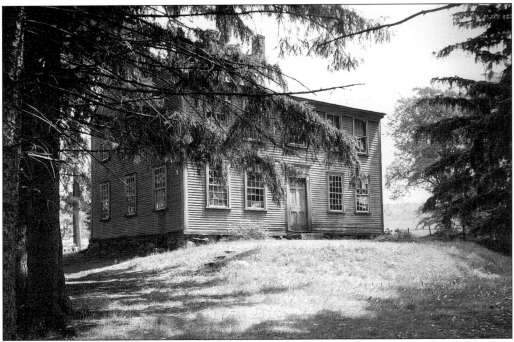

The Abram Handley House is now at 698 Main Street; however, it was originally at 17 Davis Road and was moved to this location c. 1970.

The Chaffin-Wheeler House stood at 340 Great Road and was vacant for a number of years before it burned one evening. The hill that it set upon was removed, and, today, there is a shopping plaza on the site.

This is a view of the Captain Daniel Davis House at 21 Davis Road with the porch. The house was one of three that stood on Davis Road and is the only one left. It is now used as an office building.

The Ebenezer Davis house was occupied by the Bellows Farm Sanatorium at 40 Davis Road, as seen in this photograph. This house was used as a sanatorium until the facility closed *c*. 1972, and it was owned by John (Dropkick) Murphy. Over the years, many noted personalities came to recover from addictions or just to recuperate. The structure was torn down a number of years ago, and, today, only part of the chimney stands.

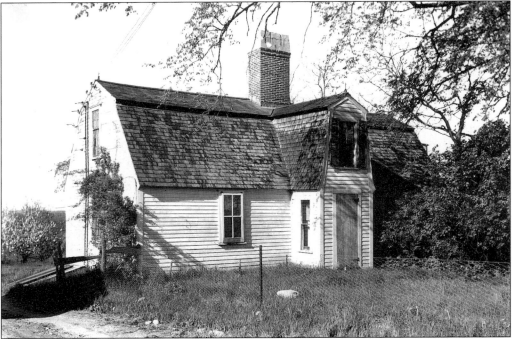

The Benjamin Brabrook Homestead was at 77 Strawberry Hill Road. The gambrel roof was a unique feature of this house, which was built in 1751. The house was severely damaged by fire about 20 years ago and torn down.

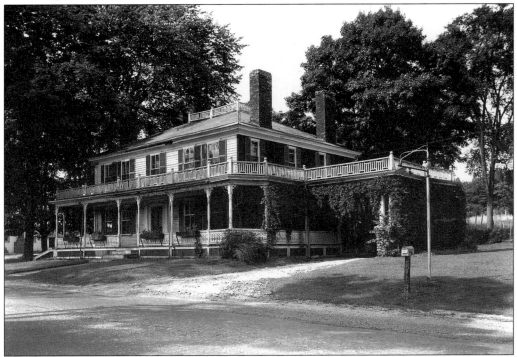

Wetherbee's Tavern, at 65 Great Road, was operated as an inn and store by Daniel Wetherbee. Wetherbee also owned the mills that were on Nashoba Brook.

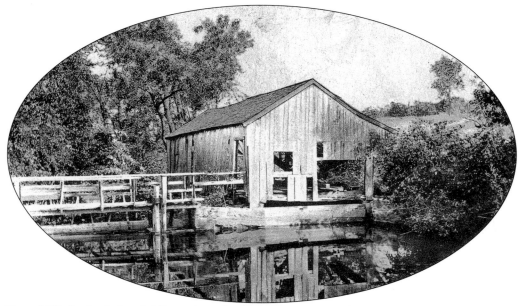

Daniel Wetherbee's Saw Mill stood on the dam at 119 Concord Road. An early mill owned by John Robbins was on this site, and this may be the actual mill. Nelson Tenney replaced the mill with a hydroelectric generating plant *c.* 1907.

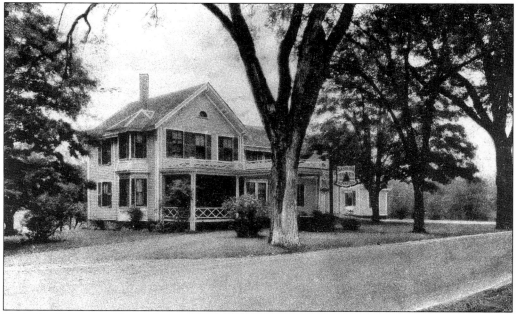

Nashoba Tavern still stands at 60 Great Road but is now a combination of offices and apartments. For a time, it was owned by Ralph Morse.

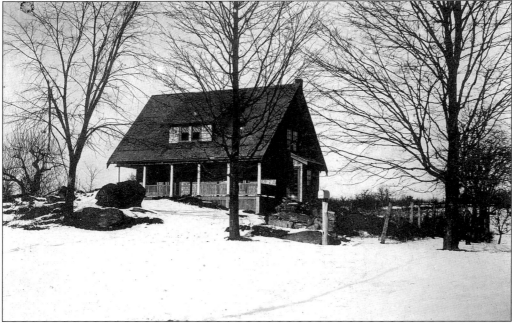

Arthur Raynor built this house *c.* 1910 at 107 Great Road. Raynor was the station agent from 1908 until 1938, when the station closed.

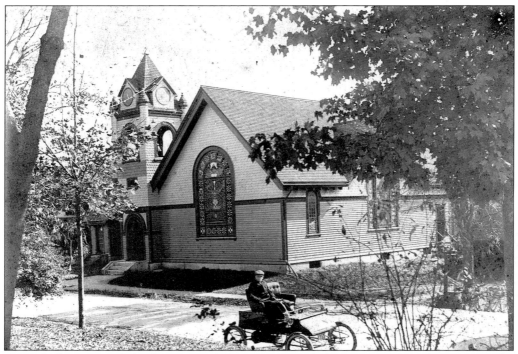

Henry Tolman owned the first automobile in Acton, and this image captures him passing the South Acton Congregational Church on School Street. The vehicle is believed to date between 1903 and 1906 and has been identified as a Stanley.

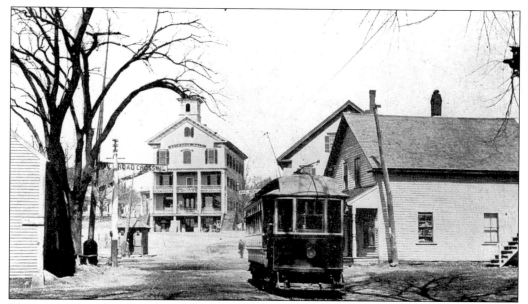

This view shows South Acton Crossing prior to the construction of the bridge. There were railroad tracks, and a streetcar joined the scene *c.* 1903. The streetcars went to Maynard and then connected with rails to other communities. The young boy with the lunchbox behind the streetcar is Edward Atherton Jones.

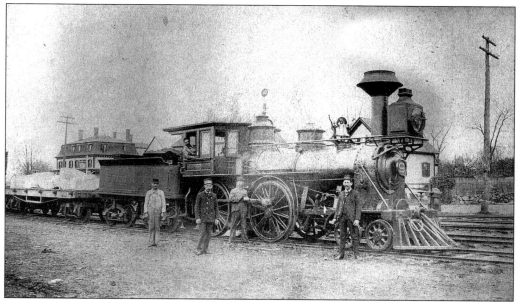

This photograph shows the building of the bridge. The engine is pulling flatcars loaded with granite for the new bridge. The American House hotel on Railroad Street can be seen behind the granite, and the building on the right is the 1845 train depot, which was moved onto Jones's farm and utilized as a fire station until 1927. (Charlotte Wetherbee.)

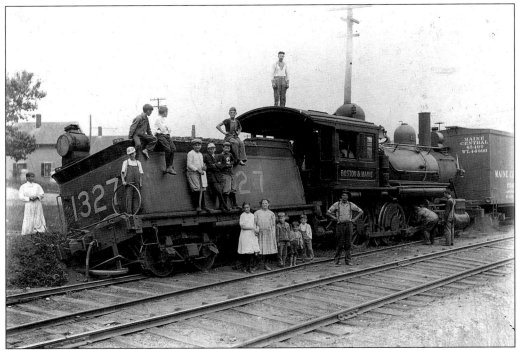

This engine walked off the tracks in South Acton and set the stage for a good picture. (Charlotte Wetherbee.)

This view shows South Acton at the completion of the new bridge *c.* 1906. The installation of the bridge involved moving several buildings and a total redesign of the area. Granite was brought in by rail, and a large amount of fill was excavated beyond the building at 20 Main Street and hauled in to elevate the road over the tracks. Barely visible beyond the bridge is the old water tower for the engines.

This c. 1915 view looks east along the railroad tracks in South Acton. There were two large spigots for filling the engines. One is quite visible on the left, and a second is in line with the boxcar in this image.

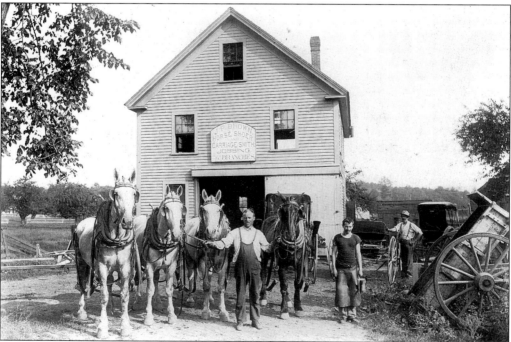

James P. Brown's blacksmith shop, located at 10 Stow Street, is shown in this photograph. Brown is posing in front of his shop with three matched horses that belonged to the Pilot Grove Farm in Stow. Brown served as a selectman for a number of years and passed away in 1938. (Charlotte Wetherbee.)

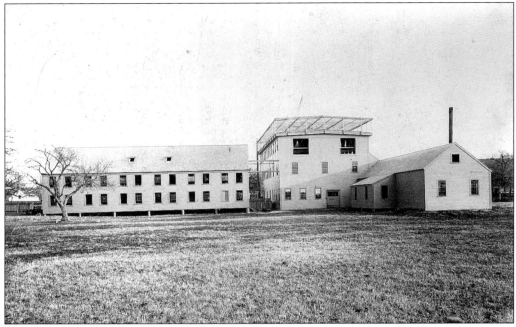

The Morocco Factory was owned by the Kimball family and produced leather products. By 1908, the market waned, and the building was used for a while by Moore and Burgess for the manufacture of webbing. After the death of Burgess, Lowell Cram became a partner, and the outfit outgrew this location and moved to West Concord. The engine house for the railroad is visible to the extreme right of this image. The factory was removed in the 1930s.

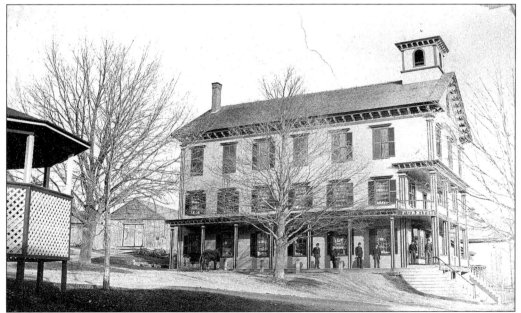

This photograph shows Exchange Hall with the bandstand to the left. With the congestion of traffic today, it is hard to imagine that a bandstand once stood on Main Street. The barn behind Exchange Hall burned in the late 1930s, along with a number of South Acton barns. This one was behind the home of Dr. Samuel Christie, who lived at 12 School Street.

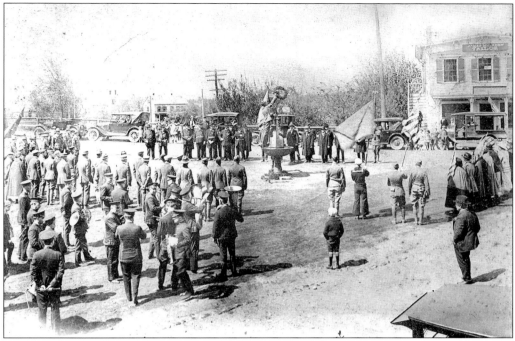

The dedication of Quimby Square took place on Memorial Day in 1920, and Quimby's name was on the horse trough that once graced the square. The plaque today is adjacent to the emergency management building, and the horse trough is at 50 Audubon Drive at the senior center. (Palmer collection.)

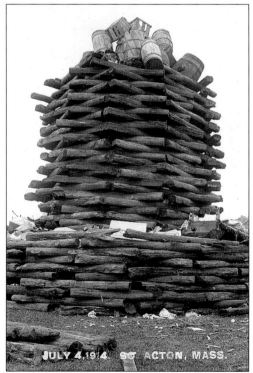

JULY 4, 1914 SO. ACTON, MASS.

At one time, Faulkner's Hill was bare, and this postcard was created of the July 4, 1914 bonfire.

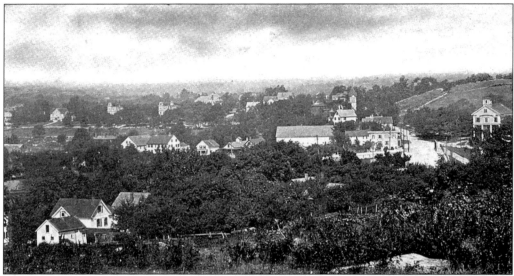

This is a view of South Acton village from Faulkner's Hill probably *c.* 1914. Exchange Hall is on the right.

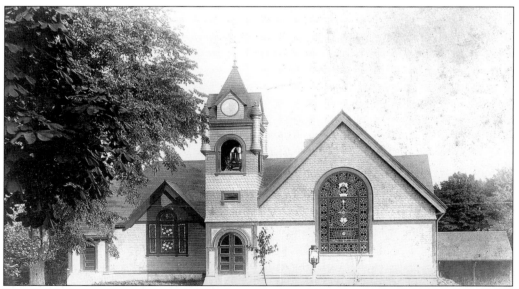

The South Acton Congregational Church was built in 1891. Founded in 1876, it first met in Dwight's Block at 27 School Street and, several years later, moved to the chapel room at the school at 54 School Street. This image is most likely taken at about this time, as it includes the horse sheds that were located at the right side of the church. (Charlotte Wetherbee.)

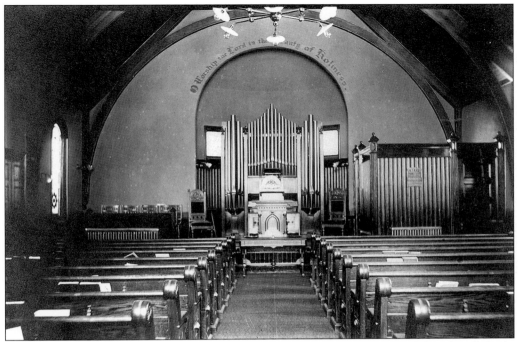

This is the South Acton Congregational Church *c.* 1920. The interior of the church looks much the same today; however, the minister's study, at the right, was removed in 1962.

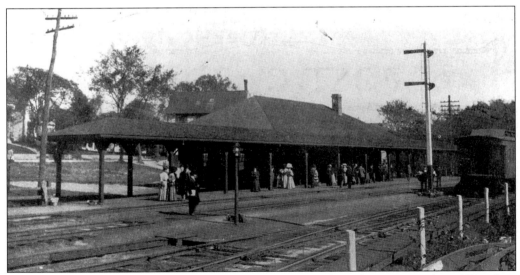

The South Acton train station was built in 1892 and served South Acton until *c.* 1970, when it was sold. Following a fire in 1984, it was removed.

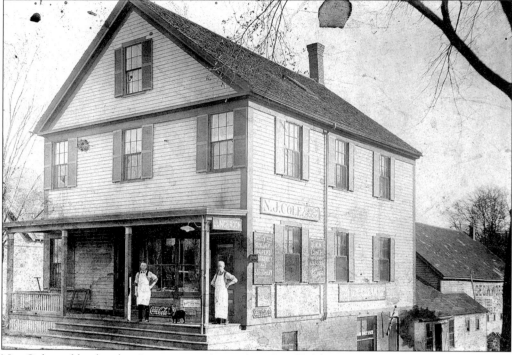

Nat Cole and his brother Jim came to Acton from Readfield, Maine. Jim drove a team, and Nat operated a lunch stand in Dwight's Block for many years. Charlie Mills is standing to the left, and Nat Cole is standing at the right end of the porch. The Cole family lived on a farm at 266 School Street, where they bottled spring water. (Information from Ron Nealey, grandson of Nat Cole.)

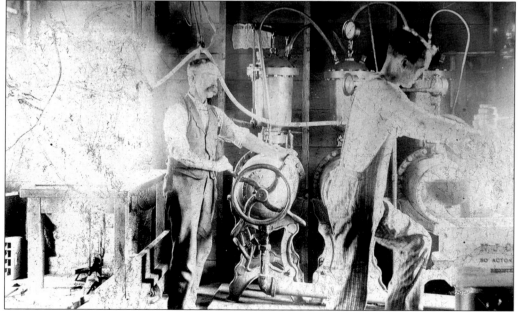

This *c.* 1900 view shows Cole's bottling plant at 266 School Street. The devices behind Cole are bottle sterilizers.

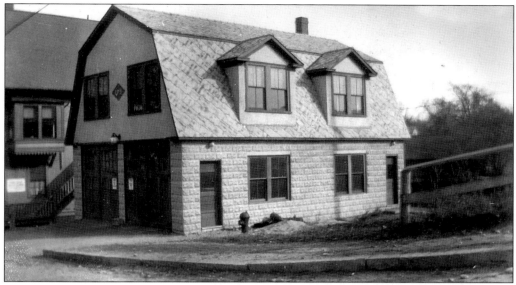

This fire station replaced the earlier one on Railroad Street and served the town until 1961. It was built by George Hayward, who was both a local carpenter and a member of the Acton Fire Department. He also served as fire chief for several years. (Author's collection.)

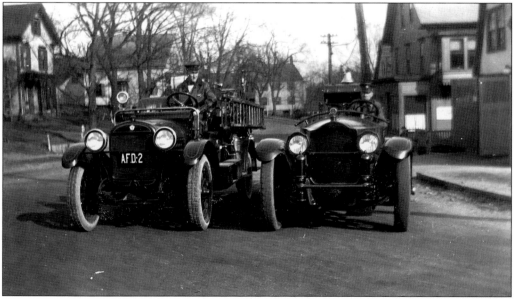

Chemical No. 2 and Ladder No. 1 are in front of the former station on School Street c. 1928. Acton bought chemical engines in 1924, and each had two 60-gallon soda-acid tanks mounted in them. When activated, the soda and acid reacted and forced water out of the tanks through the hose. If the personnel were extinguishing a small fire and all the water was not required, the extra water went out the closest window, as there was no way to shut off the supply. If a shutoff were installed, the tanks would rupture. Both pieces of apparatus met their fate in separate fires—the engine in 1948 and the ladder in 1953. (Author's collection.)

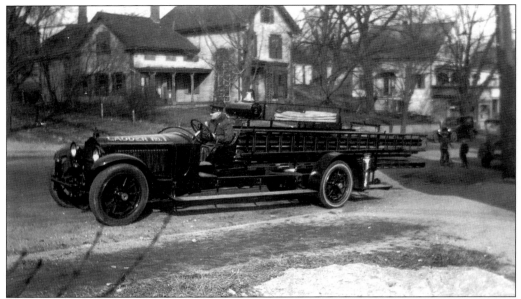

Ladder No. 1 was constructed on a Packard truck chassis by Don Fullonton, Earl Hayward, and David Clayton in 1928. Both Hayward and Fullonton had a machine shop, and all were very competent craftsmen. (Author's collection.)

Dr. Samuel Christie, Mrs. Christie, their son Robert, and Elmina A. Glines are seen in front of the Christie house at 12 School Street c. 1910.

This was the home of George Worster at 1 River Street. There are three people sitting on the porch, and Worster is on the left.

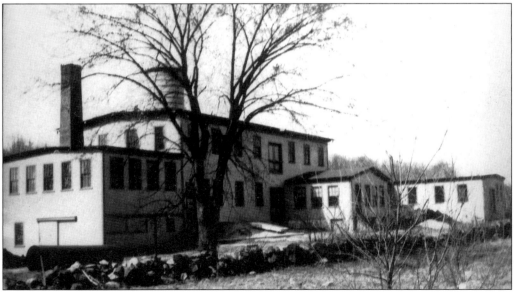

Frank B. Lothrop built a new factory in 1902 on the site of the former mill site, where Chadwick and Merriam had their mill. This company managed to survive the Great Depression and, during World War II, made several items necessary for the war effort. Lothrop produced paint brush ferrules.

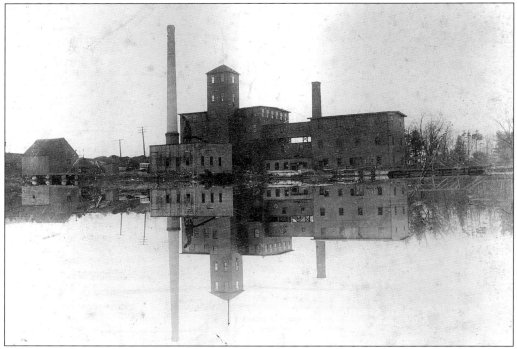

Following a second fire in 1895, the A. Merriam Company, successor to Chadwick and Merriam, bought water rights at 115 River Street and erected a new factory at this location. At this site they produced piano stools, benches, and, at a later time, radio cabinets. Airplane propellers were produced during World War II.

The American Powder Company office was located at the corner of Powdermill Road and Sudbury Road and still exists in an altered form. It is shown in this image with the horse trough, which is no longer there.

The Hansen Farm at 267 School Street was later owned by Edwin Christofferson. The barn is no longer in existence.

The Quimby-Davidson House, at 186 School Street, is shown here. The view is deceiving, as the adjacent property has houses on it and the barn and outbuildings no longer exist.

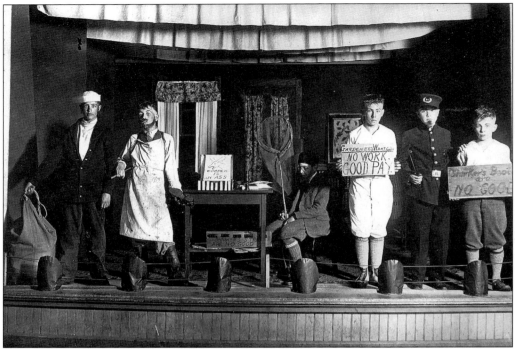

Troop No. 1, Boy Scouts of America, presented a play entitled *The First Day of the Holidays* c. 1924 in the South Acton Universalist Church vestry. The cast included, from left to right, Emerson Chickering, George Clayton, James Edney, Clarence Frankel, James Farrar, and Billy Roche.

The house at 86 School Street was built as a one-room schoolhouse in 1797 and was replaced in 1846. The building was moved back on the lot, and it became a private dwelling. This is how the building looked in 1903. Standing in front of the house are, from left to right, Bertha Merriam, her daughters Florence and Irene, son Harold, and the dog Raggs.

On May 30, 1908, there was a 70th birthday party for Angelia Tuttle Robbins (Mrs. Edward Nelson Robbins). It was hosted by her daughter at the Hayward Homestead at 45 Stow Street. In the photograph are, from left to right, the following: (front row) Nettie Hayward, a young child, Gladys Hodgen (sitting on the ground), Florence Merriam with a child, Mrs. Lowden and daughter, Alberta Hodgen in a chair with a child, Mrs. Vinnie Crosby and Mabel in her lap, Angelia Robbins, Mrs. Clarence Chickering and Grace, Ethel Fullonton and Ruth, Mrs. Ralph Simms, and Ralph Evie Willis; (back row) Mrs. Samuel Christie, Etta Temple, Mrs. McGreen, Emma Quimby, Mrs. John Case (Natalie behind her by post), Mrs. Hawks, Eva Sawyer, Lizzie Bumbus, Carrie Wetherbee, May Wetherbee, Lizzie Richardson, Mrs. George Hodgen, Mrs. Wetherbee, Mrs. Willie Fletcher, Mrs. Arthur Lowden, Mrs. Bird, and Mrs. Ham.

Sunshine Villa is over the entry at this residence at 64 School Street. The house has changed very little over the years.

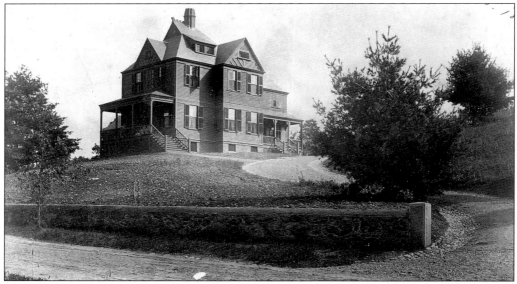

The Henry Barker residence, at 167 Main Street, was owned by Henry Barker, who owned the Barker Cider Mill in South Acton.

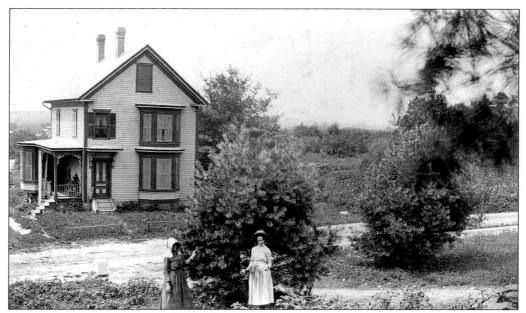

This image of the Reuben Hayward House, at 158 Main Street, is dated July 1887.

This image is of 196 Main Street, the old Moulton place. The house still appears this way, but the building in the back and the fence are gone.

Left: Daniel and Hannah Hennessey bought the Puffer Farm, at 88 Prospect Street, in 1896. Both were born in Ireland and met in Acton. Previous to their marriage, Hannah had worked at the Monument House in Acton Center. The farm consisted of 50 acres. The land where Acton Ace Hardware, the water tower, Hennessey Drive, and St. James Circle are located is on a portion of the farm. Their son and daughter operated the farm in later years. (Peggy Hebert collection.) *Right:* Tim Hennessey is seen with his first Ford automobile *c.* 1920. Hennessey and his father ran their dairy farm for many years, and Hennessey likely has the distinction of having the last dairy farm in Acton. (Peggy Hebert collection.)

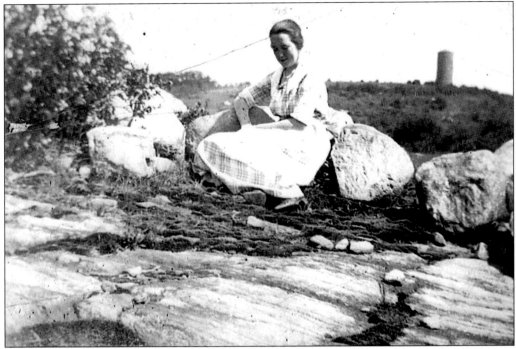

Taken on Hennessey Drive, this view shows Lena Hennessey sitting on a ledge on the family farm with the water tower in the background. Lena later married Bill Sexton of Maynard and had two daughters, Elizabeth (Betty Saganich) and Mary (Peggy Hebert). (Peggy Hebert collection.)

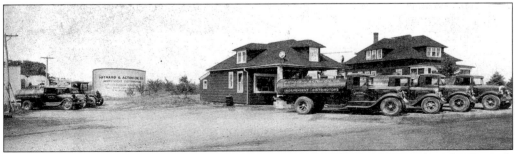

Henry W. Bursaw started Maynard & Acton Oil Company and, in 1932, issued a calendar with this image of his enterprise and vehicles. The house to the right and the tanks in the rear still exist at 64 and 70 Central Street.

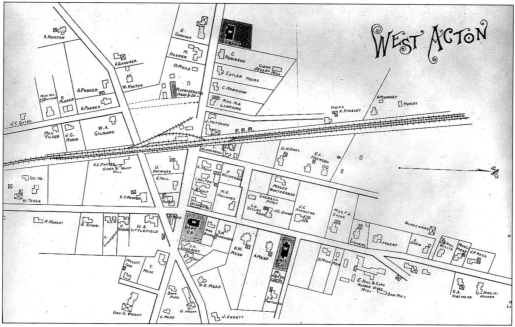

This 1889 map of West Acton shows the principal property owners and how much development had occurred by this date.

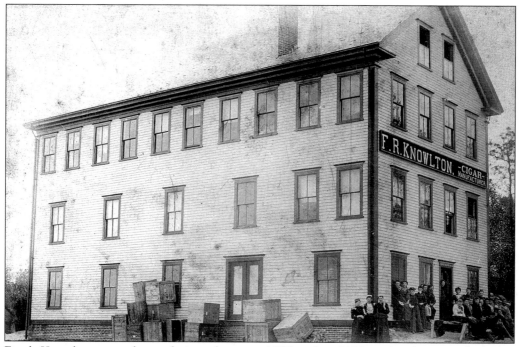

Frank Knowlton manufactured cigars between 1889 and c. 1922 at this factory, which was located at 520 Massachusetts Avenue, where the foundation is still visible. Although we do not associate this area with tobacco products, it is noteworthy that the foundation of another cigar shop is still visible on River Street in South Acton, and there was another cigar factory in West Concord.

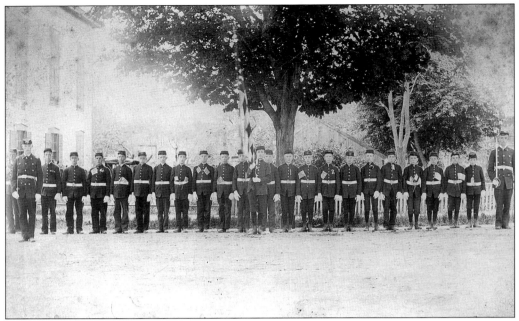

This image, taken on Memorial Day 1893, shows the "Boys Brigade" in West Acton. The building on the left appears to be the Baptist church, and there are a couple of structures in the background. The blacksmith shop of Samuel A. Guilford may be the structure behind the tree.

Ed Swift sold meat out of this wagon. He is on the left, and this image was taken in West Acton. A similar photograph exists of Swift's horse and vehicle in South Acton.

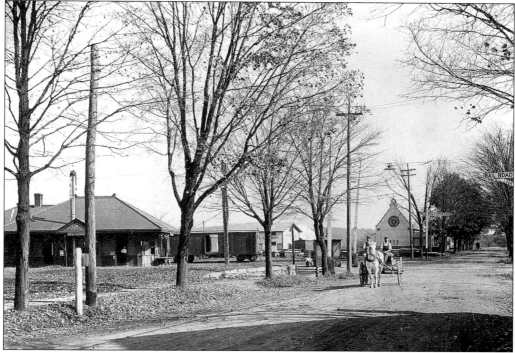

This is a view of the West Acton train station taken from the front of 570 Massachusetts Avenue looking toward Spruce Street. The man standing in the doorway is Clarence D. Cram, the station agent, and the two men in the wagon are Len Richardson and Bert Hall. The train station and church both had slate roofs that may have helped to retard the spread of fire to each structure.

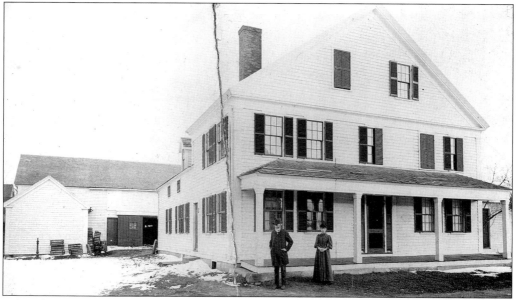

Luke Blanchard's house and barn were located at the easterly corner of Massachusetts Avenue and Windsor Avenue. To the rear is a barn in which a fire originated that destroyed a portion of West Acton.

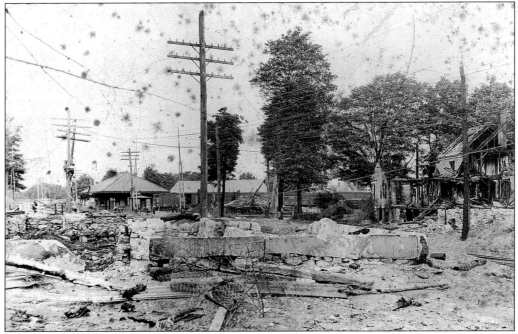

On July 1913, a fire originated in Blanchard's barn, which paralleled the railroad tracks at the corner of Massachusetts Avenue and Windsor Avenue. In the foreground is the foundation of the barn. A westerly wind carried burning embers to the Hutchins home across the tracks on the right and ignited the house and barn.

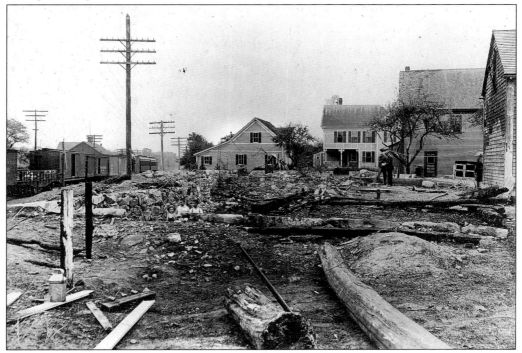

The fire totally burned the barn and a couple of other structures on the property. The second building on the right is the original fire station at 18 Windsor Avenue.

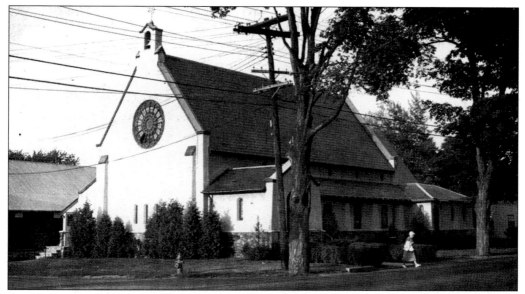

St. Elizabeth of Hungary Church was dedicated on September 21, 1913, and was near completion at the time of the July 22, 1913 fire in the adjacent area. The exterior of the building was stucco and had a slate roof, and the firefighters protected the building with hose streams to keep it from damage. Phalen's *History of the Town of Acton* tells us that "beginning in the late 1800's there were Masses once a month at first and later every Sunday in the G.A.R. Hall above 590 Mass. Avenue until the church was finished. At first, this was a Mission church and was affiliated with St. Bridgets Church in Maynard and became a separate parish in 1945." The congregation outgrew the building, so the present church was built at 89 Arlington Street.

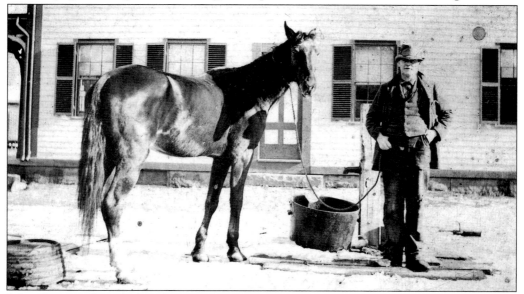

John T. McNiff worked with Samuel Guilford early in the 20th century. Guilford had an established blacksmith shop at 274 Arlington Street and was getting up in years. McNiff continued to operate the blacksmith shop following Guilford's death in 1921; however, it is not known if he remained here or for how long. John McNiff also served as a police officer from 1916 until 1933.

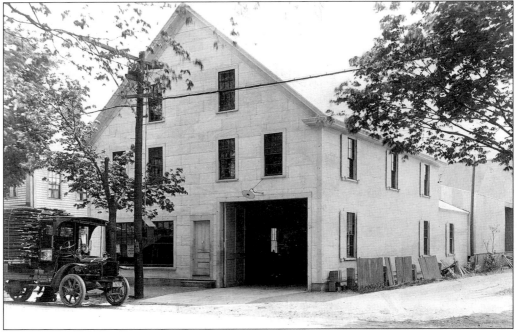

The Davis-King Trucking Company was owned by Alfred Davis and Benjamin King, and this building was located at 576 Massachusetts Avenue adjacent to the Windsor Hotel, which is on the left in this photograph.

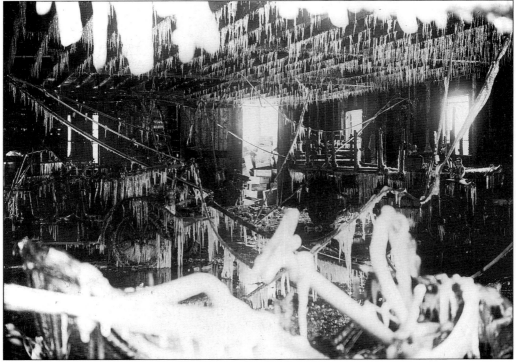

On January 18, 1914, the garage burned, and this photograph was taken after the fire. The building was repaired, but the five vehicles inside were a total loss.

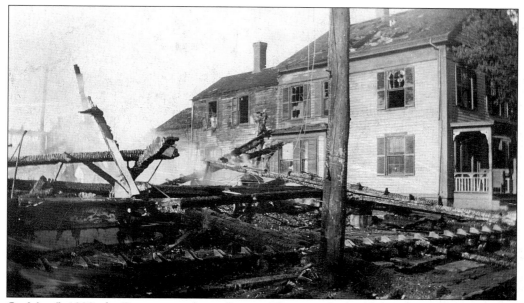

On May 5, 1922, the Davis garage burned again. This time the building could not be saved and was a total loss. In addition, the adjacent Windsor Hotel, a large barn and a double house, were destroyed in the fire. (Acton Fire Department.)

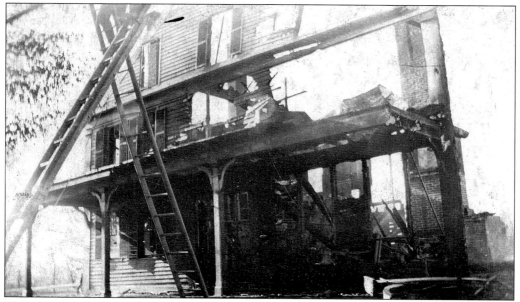

This photograph shows the Windsor Hotel in ruins. By the time the fire was extinguished, the façade of the hotel was standing, but the rest of the building was a total loss. The hotel was on Massachusetts Avenue at Windsor Avenue. (Acton Fire Department.)

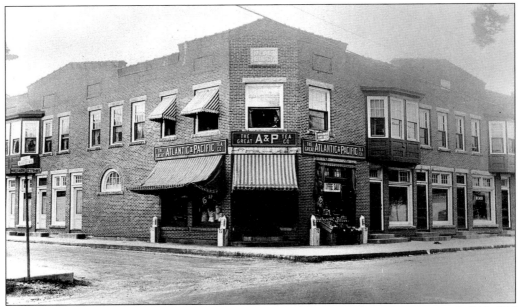

The Meads built the Mead Block between 3 and 7 Windsor Avenue and 568–576 Massachusetts Avenue on the site of the hotel and garage. It was occupied at first by the Great Atlantic & Pacific Tea Company (A & P), as shown in this image of the period. In addition, the West Acton Post Office was in the middle of the block and a restaurant to the right.

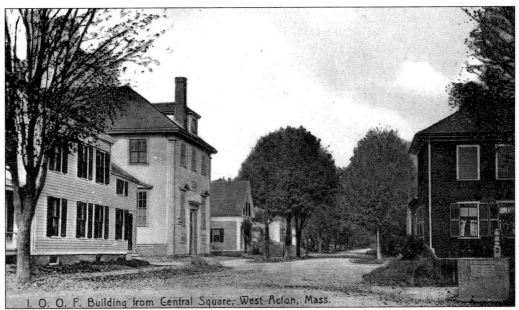

I. O. O. F. Building from Central Square, West Acton, Mass.

This is a postcard of the intersection of Massachusetts Avenue and Central Street. The house on the extreme left was in the triangle and later moved by Mead to 5–11 Spruce Street to improve visibility. The triangle was given to the town by the Meads as a town common after the building was removed, and the horse trough to the right was moved onto the common. Beyond the intersection of Arlington Street is the Odd Fellows Hall, and the next house beyond has been removed.

This is a view of Massachusetts Avenue between the railroad tracks and the intersection of Central Street. The shed on the left is attached to the Bradley Stone House at 585 Massachusetts Avenue. The grocery store used to be Strong and Tracy's at 583 Massachusetts Avenue. The house beyond the store belonged to Hap Reed and was located where the Middlesex Bank is at 577 Massachusetts Avenue, and the last house to the right was the James Hayward house, where Acton Pharmacy is.

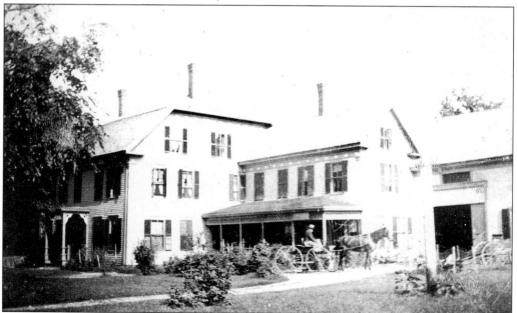

The James Hayward house stood at 569 Massachusetts Avenue. The large imposing house remained in the family, and his granddaughter Lizzie Burroughs was the last family member to live here. The house was taken down and is now the site of Acton Pharmacy.

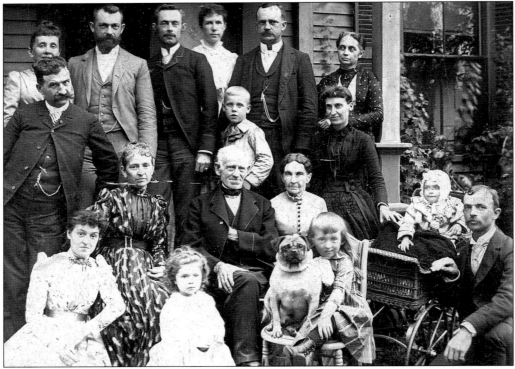

This photograph of the James W. Hayward family was taken at their home at 569 Massachusetts Avenue. Included in the photograph are James Wood Hayward; his wife; sons Webster, Frank, and Charlie; Abbie; Raymond; Frank C. Hayward; Hattie; Ed; Dora; Ida; Elizabeth, who married Henry Hanson of 267 School Street; Ella A. Burroughs; Samuel Burroughs; and Mabel and Lizzie Burroughs with dog Button. This picture was taken on August 22, 1890, and Lizzie Burroughs was the last family member to live here before the house was demolished.

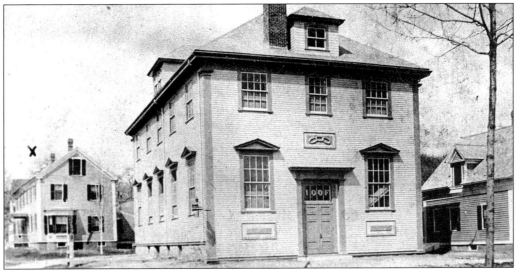

This is a view of the Odd Fellows Hall at 282 Central Street as it appeared c. 1907. This building was also used as a theater for movies and, at a later period of time, was a cold storage plant for the Jenks family. The building was converted into office space a number of years ago.

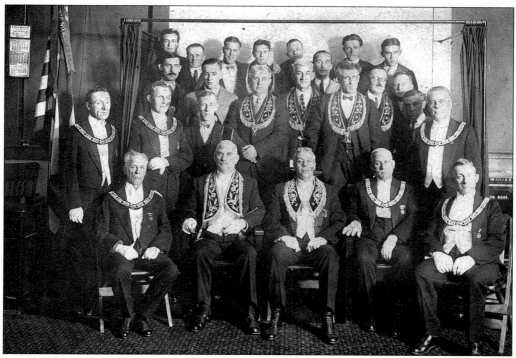

Odd Fellows pose in an undated photograph.

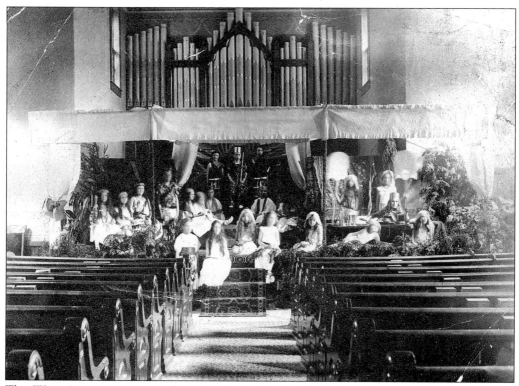

This West Acton image was taken of a play inside the West Acton Baptist Church in 1917.

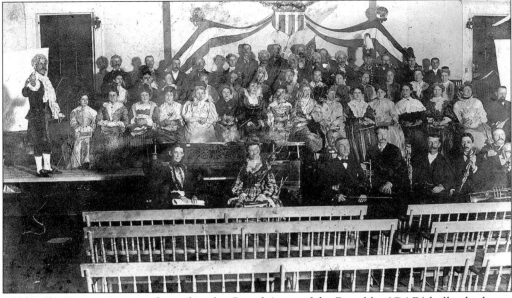

"Old Folks Concert" was performed in the Grand Army of the Republic (GAR) hall, which was on the second floor of the Mead Store located at the corner of Central Street and Massachusetts Avenue. The hall is office space at this time.

Factory workers are seen here at Hall Brothers with the pails, butter churns, and woodenware that were produced at the mill at the intersection of Central and Willow Streets. This image dates from *c.* 1920.

John T. McNiff with the first issue of Acton Police Department uniforms lived at 46 Summer Street. He was also a blacksmith who worked at the blacksmith shop at the corner of Arlington Street and Massachusetts Avenue. His grandson John McNiff is a lieutenant on the Acton Police Department. (John McNiff.)

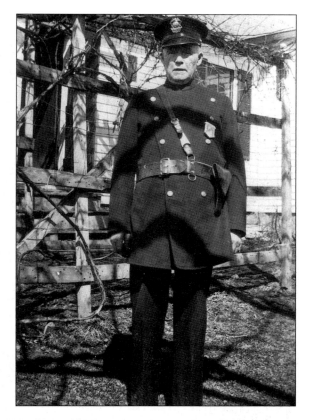

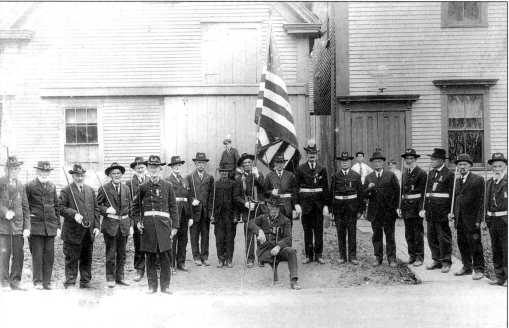

This image of GAR veterans is undated but was taken in West Acton, most likely c. 1915 on Memorial Day.

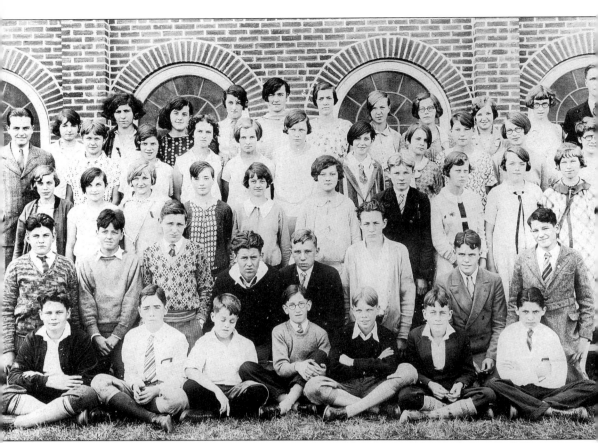

Acton High School students pose at the rear of the building. From left to right are the following: (first row) David Young, Irving Dunn, Walter Byron, Hobart King, Roy Thompson, William Condon, and Walter Lawrence; (second row) Albert Sadler, George Coombs, Wendell Berglund, George Richardson, Cecil Hudgins, George Clayton, Lyle Reynolds, and unidentified; (third row) Wilma Thompson, Doris Cunningham, Allison Massie, Patricia Sherry, L. Sawyer, Mary French, William Massie, Alice Parker, Louise Ineson, and Marian Laird; (fourth row) Victoria Grala, Dorothy Davis, Mable Stuart, Leota Baker, Annie Bulette, Helen Mekkelson, Virginia Roache, Pauline Flerra, Alice Lawrence, and Margaret Heath; (fifth row) Richard Hood, Mary Tompkins, Mary Mauro, Mary Duggan, Elsie French, Ella Livermore, Virginia Gorton, Agnes Andersen, Mary Soares, M. Christiansen, Eleanor Morison, and Walter Holt.

Three

1936–1985

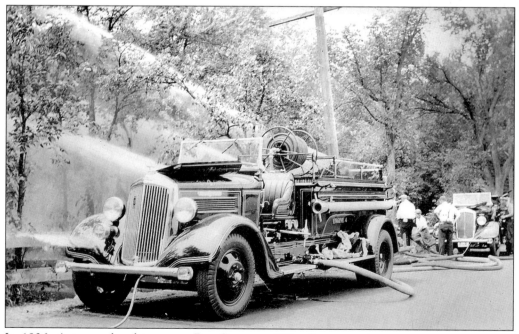

In 1936, Acton ordered two new Reo-Seagrave 500-gallon-per-minute pumpers at a cost of $4,000 each. They were numbered Engine No. 3 and Engine No. 4 of the Acton Fire Department. (Acton Fire Department.)

"The Cup" was at 132 Great Road but is no longer a restaurant. It was owned by Stuart Allen, who owned the house at the dam on Concord Road. Allen was also the owner of the Allen Chair Company in West Concord.

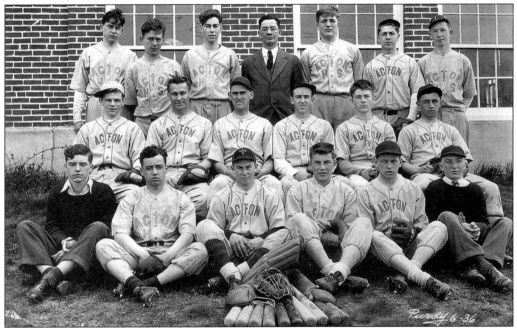

The Acton High School baseball team won the Sudbury Valley Championship in 1936, when this photograph was taken. From left to right are the following: (front row) R. Spinney (manager), G. Gilbert, Russ Hayward, Earl Hayward, L. Thatcher, and G. Brennan (assistant manager); (middle row) F. Roche, S. Bondelevitch, Fred Lawrence, Leo Cunningham (captain), C. Gallagher, and A. Gilbert; (back row) Jim Merriam, H. Dunn, J. Smith, Robert Dolan (coach), Wilson Bursaw, Wilbur Tolman, and R. Taylor.

On September 21, 1938, New England was the host of a hurricane that caused millions of dollars of damage in the area. Some of the trees at the South Acton School came down, and it appears that they all missed the building.

This view shows hurricane damage at the Mead Triangle in West Acton. The house behind the tree was removed to enlarge the church parking area.

The tree missed the barn in this image taken after the Hurricane of 1938; however, the barn was destroyed by fire during the summer of 1963, and the house still stands at 471 Massachusetts Avenue.

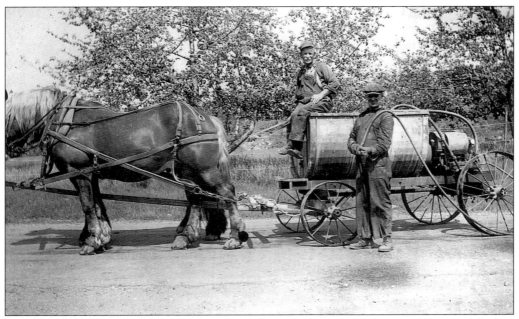

Daniel and Tim Hennessey, with their horse-drawn spray equipment, were photographed in their orchard in 1940 at their farm on Prospect Street. (Peggy Hebert collection.)

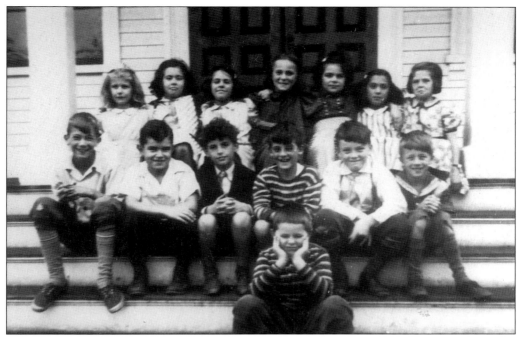

This photograph was taken at the West Acton Grammar School in 1941. Known to be in the picture are Robert Howe (on the front step), Douglas Gravlin, Richard Flint, Francis Flerra, Stephen Peterson, Robert Learmouth, Keith Peavy, Jeanette Reynolds, Norma Pendergast, Dorothy DeSouza, and Phyllis Smith.

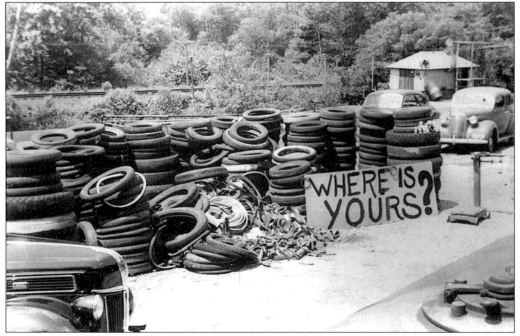

During World War II, a great effort was made to recycle any item that could be used to make sure that we could help win. This image was taken at Bursaw Gas and Oil at 94 Great Road, where tires were collected. (Bursaw collection.)

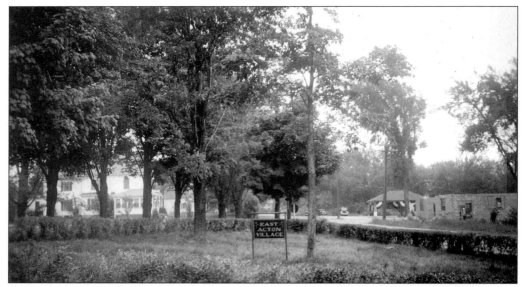

East Acton Village is shown here sometime prior to the widening of Great Road. Bursaw Gas and Oil is in the background and the company's repair garage is under construction in this photograph. The East Acton Common was a triangle starting at the present triangle and extending toward Bursaw's. Stuart Allen provided the shrubs and other plantings, and Arthur Raynor, the East Acton station agent, maintained the property.

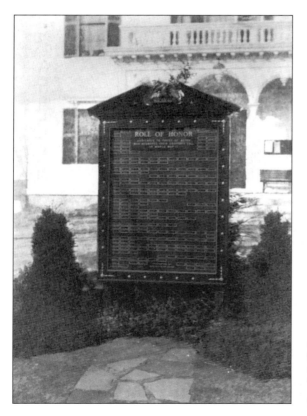

A World War II Roll of Honor with the names of all who served in the war was erected in front of the Acton Town Hall. It remained here for many years until removed for repairs.

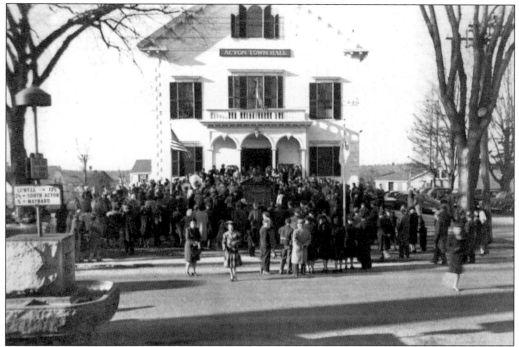

This is a photograph of the dedication of the World War II Roll of Honor.

The store at 16–20 School Street had a variety of owners in the 20th century, including the Tuttles, Lowdens, Jim Connolly, and, finally, Peter Smoltees. Smoltees is standing in front of his store, and the Home Pet Shop on the right was owned by Doris Soar, who started the business at her home at 78 Main Street and moved it here c. 1954. She was at this location for a short time and moved the business to West Acton, and the Owl Shop was the next tenant.

Peggy Sexton and Bill McMahon are shown with her uncle Tim Hennessy (holding his horse Freddie). (Peggy Hebert collection.)

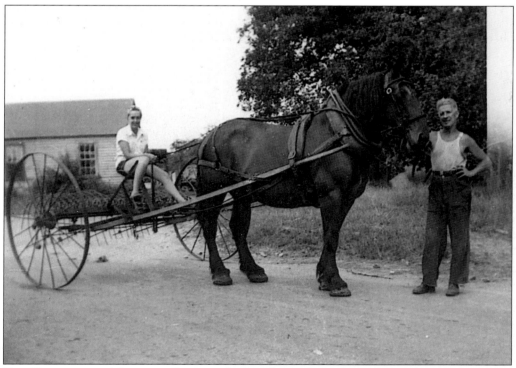

Tim Hennessey and his niece Betty, with their horse-drawn hay rake, took a break for this photograph, taken at 88 Prospect Street. (Peggy Hebert collection.)

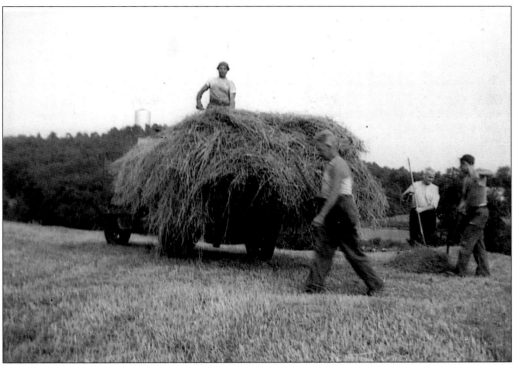

After the hay was cut, it was left to dry, raked into rows, put on Tim Hennessey's truck, and taken to the hay loft above the cows in the barn. In this photograph are, from left to right, Joe Mack, Tim Hennessey, Charlie Spencer (in the white shirt with a hayfork), and Spencer's son Charlie Jr. The Spencers lived next door at 138 Prospect Street.

This photograph taken at Hennessey's in the 1950s includes Ronnie Hayes, Peggy Sexton, Sylvia Beaudoin, and Jerry Davis. (Peggy Hebert collection.)

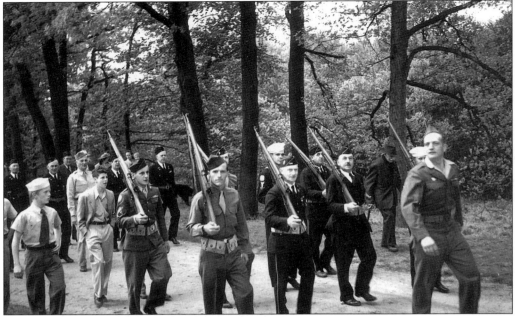

This is a photograph taken on Memorial Day in 1947 with Bill Merriam, commander of the American Legion Post 284, leading the parade.

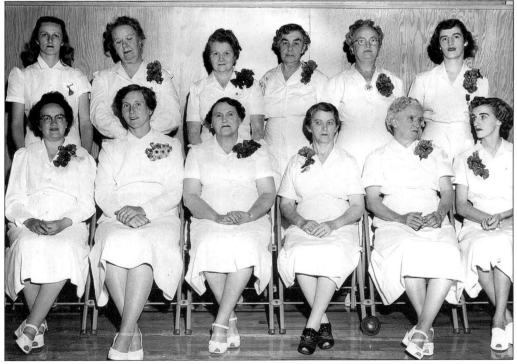

This photograph is of the American Legion Auxiliary *c.* 1950. From left to right are the following: (front row) Mabel Grekula, Kay Nedza, Jane Kiley, Doris Horton, Dot Reed, and Joyce Feltus; (back row) Marjorie Merriam, Doris Linscott, Mrs. Croft, Nellie Crosby, Thelma Leusher, and Libby Fairbanks.

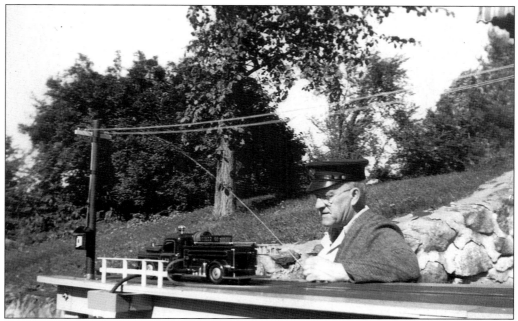

Earl Hayward was a machinist and had a shop next to his house at 30 Stow Street. He built some models and, *c.* 1946, constructed a working model fire engine, complete with a road, a water source, and a station. The model was set up outside his home and is shown here pumping water. He joined the Acton Fire Department in 1927.

Richard Deane built this combination filling station and repair garage *c.* 1950 at the intersection of Main Street and Prospect Street. Today, this is Prospect Street Mobil, but this is the way the land looked prior to the construction of Acton Supply, which opened on December 1, 1955. The house on the left is David Tuttle's. The barn was Tim Hennessey's, and the houses on the right are hardly noticeable due to landscaping. (Mike Lafoley and Kevin Whalen.)

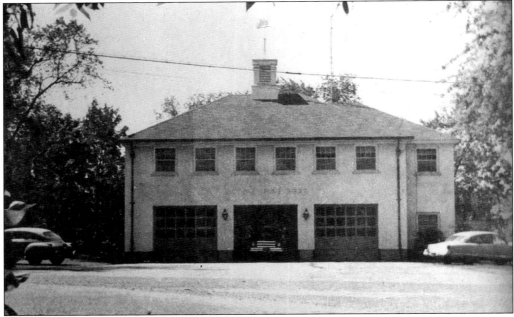

The town built a new fire station at 7 Concord Road in 1951. The new station was built by Jenny Brothers behind the old building, which was torn down at the completion of the new station.

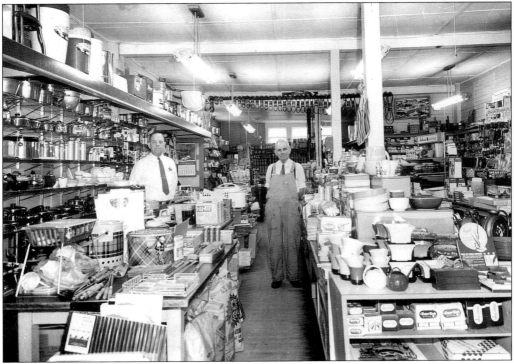

Norman McAllister owned the Town Shop in West Acton, which was later owned by Bernard Pond. McAllister is on the left, and William Houghton is on the right. This is in the same shop that L.U. Holt had in an earlier image (page 41).

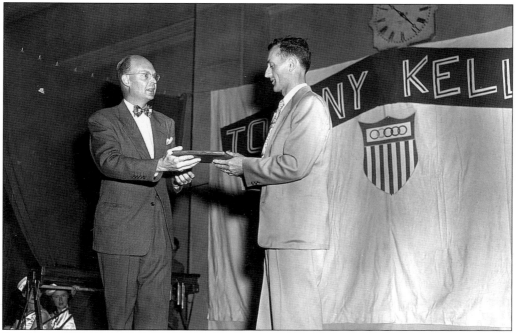

In 1948, Johnny Kelley, then living in West Acton, was on the U.S. Olympic team, and this image was taken at that time in the Acton Town Hall with a presentation from selectman George Braman. Kelley is a legend in the Boston Athletic Association Marathon.

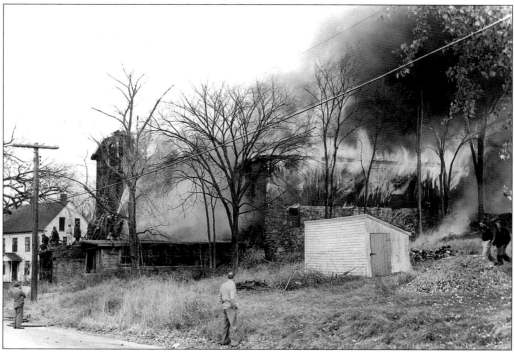

On October 27, 1951, the cider mill burned and was no match for the fire department resources. The shed in the foreground is on the Universalist Church property, and the house in the background is 11 Central Street. (Acton Fire Department.)

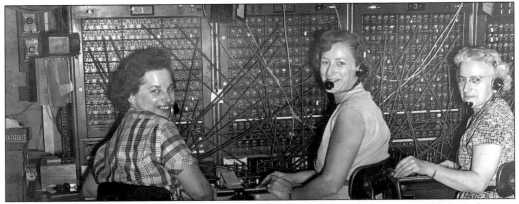

The telephone company used to be located in the Bradley Stone house at 585 Massachusetts Avenue, and two images have survived that were taken in 1952. In this photograph are, from left to right, Arlene Hayward, Doris Parker, and Laura Davis.

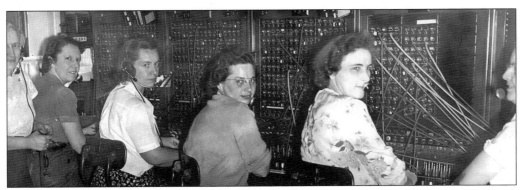

Shown, from left to right, are Laura Davis, Dorothy Gothrope, Ruth McNiff, Arlene Hayward, Phyllis Webb, and Lillian Feltus Gallant.

This view of Taylor Road was taken by Philip Vanderhoof *c.* 1953 looking toward Acton Center from about 75 Taylor Road. The two barns belonged to William Dunn and both have been taken apart and moved elsewhere. The house and barn to the far left are at 49 Taylor Road. The second barn was taken to Carlisle by Robert Kendall to become a private residence. The barn to the right was dated from the 1700s and became one of the buildings at the Old Mill Restaurant in Westminster. (Scott D. Vanderhoof.)

This is a classroom view of Florence Merriam's first-grade class of 1952–1953. From left to right are the following: (front row) Grace Cobleigh, Grace Jones, Carol Jackson, and James Tinker; (back row) Marilyn LeClerc, Giles Lowden, Lorraine Sweetser, Dorothy Rahberg, Judith Nordberg, Kenneth Johnson, Kenneth McKelvie, Lucius Tolman, unidentified, Russell Troupe, and Patricia Curtin.

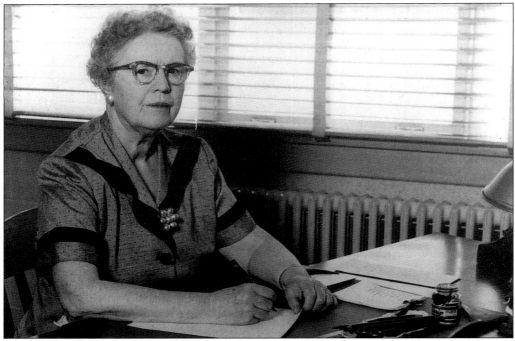

After 49 years as a teacher, Julia McCarthy retired in 1955. At the time of her retirement, the school committee honored her by naming the new elementary school the Julia McCarthy School. This was the first school to be named after a teacher. (McCarthy Elementary School.)

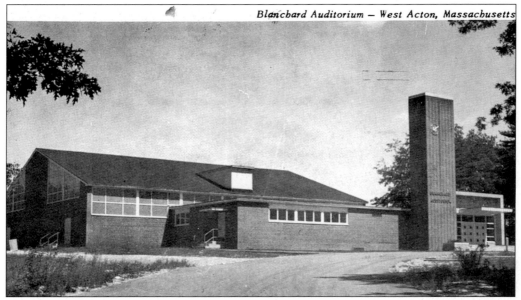

Blanchard Auditorium – West Acton, Massachusetts

The Arthur F. Blanchard Foundation provided a grant of $150,000 to build a civic auditorium in town, as there was no facility capable of providing a large facility for school athletics and other functions. The Town of Acton matched the grant with $173,000, and the Blanchard Auditorium was completed in 1955. The building was used for town meetings for a number of years. Following the completion of the Acton-Boxborough Regional School, the auditorium became the gymnasium for the school and was later attached by a corridor.

Arthur F. Blanchard lived at 56 Windsor Avenue and his son
Webster lived next door at 62 Windsor Avenue. Both had
been highly successful businessmen and founded the Blanchard
Foundation in the late 1940s. The fund continues today, and
the Blanchard School in Boxborough and the Blanchard
Auditorium are two public buildings that the fund has been
associated with.

Acton Supply opened at 220 Main Street in December 1955 and, at the time, was owned by
Dan Flanagan and John LaFoley, his son-in-law. The business had formerly been at the
Erikson's Grain Mill. The South Acton Post Office also moved into this building and occupied
the extreme right section of the building until a merger of the three individual post offices.
(Mike LaFoley and Kevin Whalen.)

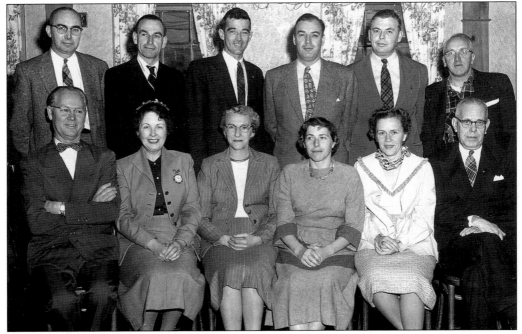

Acton Republicans met with Lieutenant Governor Whittier in January 1956 and, of the event, this group photograph survives. From left to right are the following: (front row) Dewey Boatman, Thelma Boatman, Madeline Schmitz, Patty MacPherson, Carol Flagg, and Lowell Cram; (back row) Charles MacRae, Norman Veenstra, Charles MacPherson, Sumner Whittier, Fred Abbt, and Richard Deane.

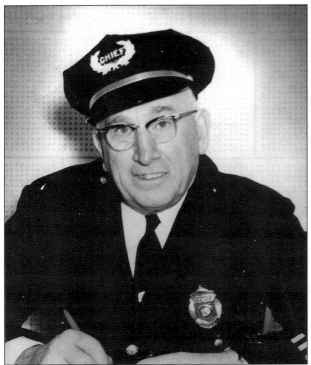

Police Chief Mike Foley joined the Acton Police Department in 1923 and, four years later, became chief of the department. He remained at that post until he retired in 1957. (Acton Police Department.)

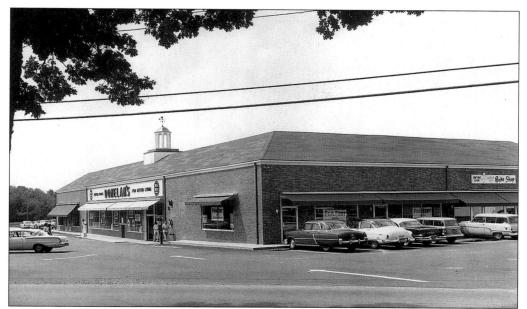

Acton's first shopping center was built at 206–220 Main Street by John LaFoley on land between Acton Supply and Dicks' Service Station. Donelan's Supermarket occupied this site between 1958 until they moved to 260 Great Road. The Rolling Pin Bakery in Littleton had a branch store at this location for a time. The barbershop is the only original tenant in this location today. (Mike LaFoley and Kevin Whalen.)

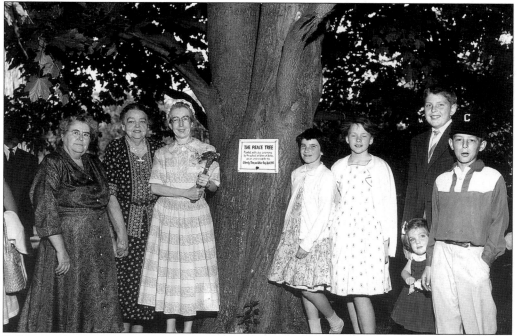

Following the decline of the original liberty tree at 24 Liberty Street, a new tree was planted, and this photograph was taken in 1959 denoting the new tree "the Peace Tree." From left to right are Margaret Larrabee, Mildred Ineson, Essie Reynolds, Jacqueline Cowley, Marion Veenstra, Bill Cowley, and John Knight.

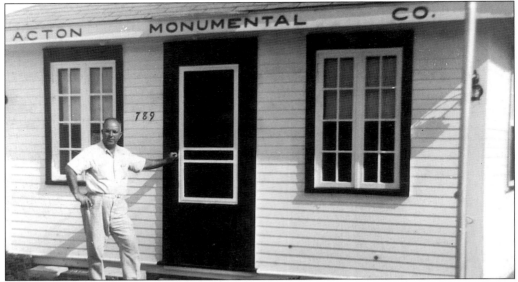

This photograph of Ray Harris was taken at the Acton Monument Company at 789 Main Street in North Acton on August 15, 1962. The Acton Monument Company origins began when Harris's father, David, formed a partnership with Timothy Sullivan and a chap named Prescott in 1882 and bought a piece of land on Quarry Road that contained excellent granite. The quarry remains abandoned today. The Harris family still serves Acton with granite for doorsteps, monuments, or any object made of stone. Ray Harris was succeeded by his nephew Fred, and Fred's grandsons now run the business following in their father's footsteps. (Acton Monument Company.)

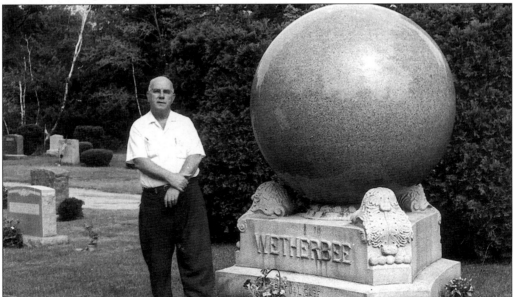

Ray Harris of the Acton Monument Company stands next to the Wetherbee Ball in Woodlawn Cemetery. Fred Harris, Ray's nephew, advised the author that the base of the monument was carved by David C. Harris from Acton granite. The ball, which weighs 11 tons, was shipped to the East Acton Depot, where D.C. Harris then moved it to the cemetery. (Acton Monument Company.)

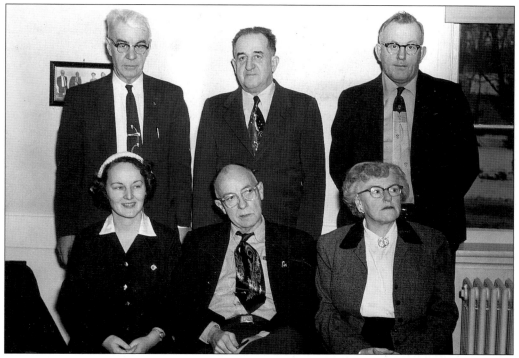

Acton Board of Health members in 1959 are, from left to right, as follows: (front row) town nurse Eileen Hale, Dr. Ormal L. Clark, and Dot Turner; (back row) Edward Higgins, Herbert Leusher, and Martin Duggan.

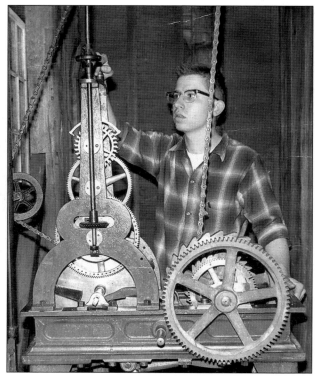

Bill Klauer began winding the town clock beginning on Columbus Day in 1961. The following February, the Acton Board of Selectmen publicly thanked him for his efforts and began paying him the $25 per year that had been voted at the November 1864 town meeting. He remained at this post until 1999, when the dials were electrified and a device installed to ring the bell. Combined, Klauer, Oliver Wood, and Arthur Wayne took care of the clock for 89 of the 100 years in the last century. (G.B. Williams.)

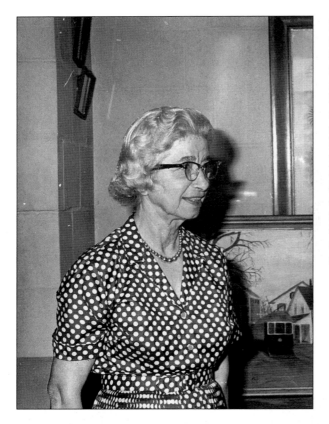

Florence A. Merriam retired from teaching at the end of June 1962. She began teaching in South Acton in 1927 and always taught first, second, or third grades. Following her career of teaching, she spent uncounted hours documenting the early acquisitions of the Acton Historical Society. The author is much indebted to her for her knowledge of the town and the scrapbooks that she created over decades, which are used constantly to determine what took place and when. Many of the images used in this publication have her initials on them.

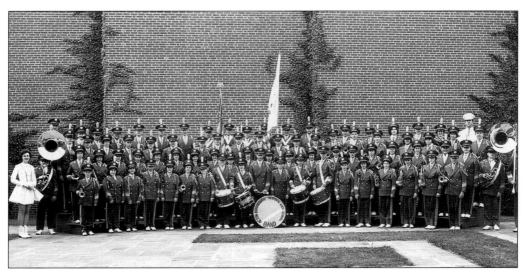

The Northeastern Music Festival was held at Acton Boxborough Regional High School on May 4, 1963, and there were 12 school bands represented. There was a parade and then performances of all the aspects of the different school programs.

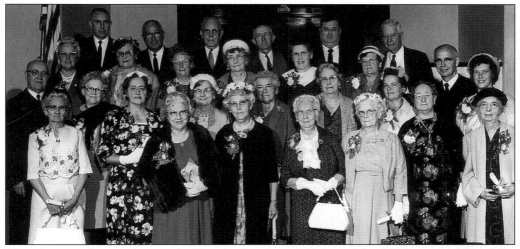

This photograph was taken at the Baptist church at the time of the 110th anniversary of the organization in 1964. Most of the people in this photograph have been identified, but there are a couple of gaps to be filled in. They are, from left to right, as follows: (first row) Jane Whitcomb, Minetta Lee, Zine Littlefield, Alice Perkins, Lois Cram, and Lizzie Burroughs; (second row) Marie Feltus, Ethel Davis, Ruth Scanlon, Mabel Jenks, Ethel King, Barbara McPhee, George Wheeler, and Ruth Feltus; (third row) Dr. Hugh Penney, Lillian Gallant, Myrtle Smith, unidentified, Marjorie Kennedy, Helen McPhee, Marjorie Flint, Hazel Hughs, and unidentified; (back row) Don Feltus, Arthur Lee, Lowell Cram, Prescott Burroughs, Albert Grimes, and Harold McPhee.

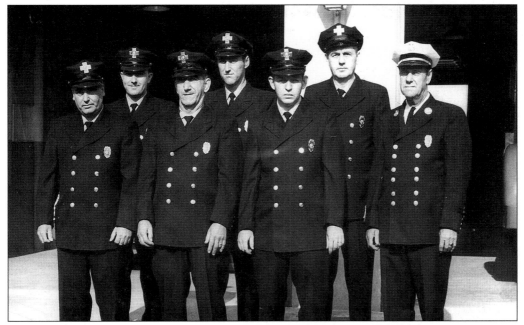

This photograph is of the first permanent firefighters. Following the 1964 town meeting, six firefighters were hired to cover each of the three stations for eight hours per day. From left to right are Ed Belmont, Don Copeland, Hobart King, Malcolm MacGregor, Skip Frost, and Charles Sweet with Chief Hanson Stuart MacGregor. Of this group, Don Copeland remained on the job the longest and retired in 2000. (Acton Fire Department.)

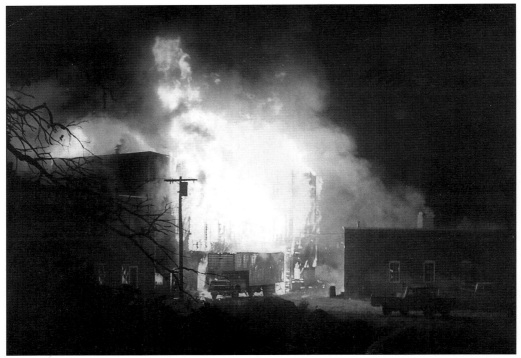

This image was captured by George B. Williams when Merriam's mill burned on September 2, 1966. The A. Merriam Company closed *c.* 1949, and the factory remained vacant for about a decade. At the time of the fire, it was occupied by Atlas Insulation, who used the building to store foam insulation. (Acton Fire Department.)

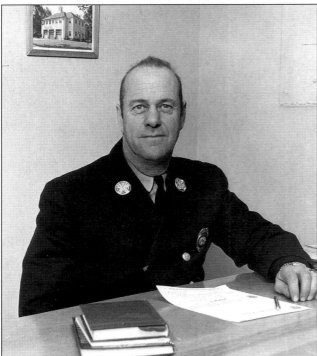

Chief Hanson Stuart MacGregor joined the fire department in 1924 and was attached to the West Acton Company. He rose through the ranks and became chief in 1933. He remained the chief of the department until his retirement in November 1967. (Acton Fire Department.)

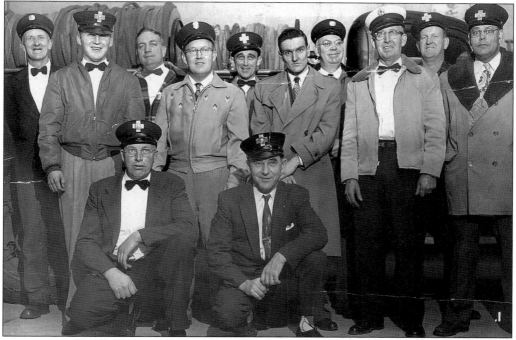

This view shows the Acton Fire Department, Acton Center Company, c. 1955. From left to right are the following: (front row) Ken Jewell and John Torkelsen; (back row) Norman Livermore, Walter Torkelsen, Wilson Bursaw, Kelly Pederson, Doc McNiff, Bill Kendall, Wendall Putnam, Clarence Frost, Walter Liebfried, and Everett Putnam. (Acton Fire Department.)

Shown in this photograph is the Acton Fire Department, South Acton Company, c. 1955. From left to right are the following: (front row) Ed Belmont, Malcolm Fullonton, Charlie Wiles, Theron Lowden, Geroge Pederson, and Wes Larrabee; (back row) Ole Garthe, Dick Lowden, Bing Priest, Charles Sweet, Allen Christofferson, Allen Nelson, Emery Nelson, Robert Nelson, and Al Braman. (Acton Fire Department.)

This is a photograph of the Acton Fire Department, West Acton Company. From left to right are the following: (front row) Walter Sprague, Orla Nichols Jr., Orla Nichols Sr., H. Stuart MacGregor (chief), and James Wilson; (middle row) Hobart King, Arthur Hirsch, Wentworth Prentiss, Frederick Harris, Raymond Gallant, Jim Baker, Arno Perkins (deputy chief); (back row) John Beach, George Allen, Fred Kennedy, Arthur Decker, and Mal MacGregor. (Acton Fire Department.)

In August 1970, William O'Connell retired as the superintendent of schools. During O'Connell's 25 years with the Acton public schools, there were 516 students in the school system when O'Connell started teaching in 1945 and, at the time of his retirement, there were 4,500.

Raymond J. Grey joined the Acton High School team in 1951 and taught social studies and English in the old high school at 431 Massachusetts Avenue. He later became the principal of the high school until 1973, when he was chosen to be the superintendent until his untimely death in 1980. Following his death, the Acton Boxborough Regional Junior High School was named to honor him for both his accomplishments within the community and, particularly, for all the students and teachers whom he always served first.

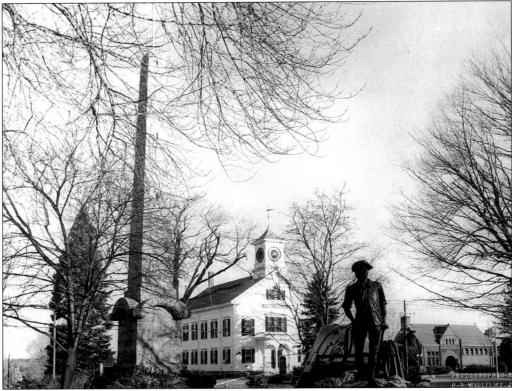

This is a photograph of the Daniel Chester French statue of the Minuteman with the Revolutionary monument in the spring of 1975. The statue was removed from Concord by the Acton Monument Company and is shown here in transit to Boston to have a mold made. (Williams photograph.)

Acton's 250th Anniversary
1735-1985

In 1985, the town of Acton celebrated its 250th anniversary. At the time, the Acton Historical Society published this broadside. A contest to design a flag was won by Bob Conquest and was used for the heading of this broadside. (Author's collection.)